Drawing with

CHARCOAL, CHALK, AND SANGUINE CRAYON

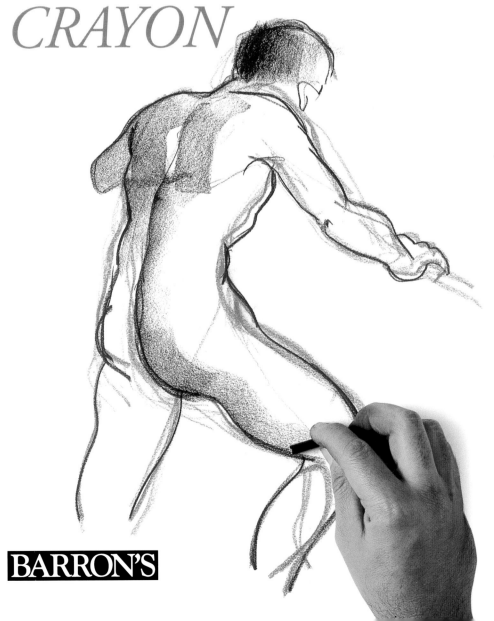

BARRON'S

Drawing with Charcoal, Chalk, and Sanguine Crayon

English language edition for the United States, its territories
and dependencies, and Canada published 2006 by
Barron's Educational Series, Inc.
© Copyright of the English edition 2006 by Barron's Educational Series, Inc.
Original title of the book in Spanish: *Dibujo con Carbón, Creta Y Sanguina*

© Copyright 2004 by Parramón Ediciones, S.A.
 Exclusive World Rights
 Barcelona, Spain
 A Grupo Editorial Norma company

All inquiries should be addressed to:
Barron's Educational Series, Inc.
250 Wireless Boulevard
Hauppauge, NY 11788
http://www.barronseduc.com

ISBN-13: 978-0-7641-5989-3
ISBN-10: 0-7641-5989-5

Library of Congress Catalog Card Number 2005909288

Editorial in Chief: Maria Fernanda Canal
Editor: Tomàs Ubach
Assistant Editor and Picture Archives: Maria Carmen Ramos
Text: Gabriel Martin Roig
Projects: Gabriel Martin
Final Editing and Writing: Maria Fernanda Canal, Roser Pérez
Series Design: Toni Ingles
Photography: Studio of Nos & Soto
Prototypes: Toni Ingles
Production Director: Rafael Marfil
Production: Manuel Sánchez

Acknowledgments
Our thanks to the Escola D'Arts i Oficis, of the Diputatión de Barcelona, to
Enric Cots, Josep Asunción and Gemma Guasch, as well as to the students
Pere Berlzuncer, Marta Campillo, Encarnación Osuna, Margarita Puig, and
Inés Rabanal for their support and collaboration in the execution of the
exercises from the section "Work by Students."

Printed in Spain
9 8 7 6 5 4 3 2 1

CONTENTS

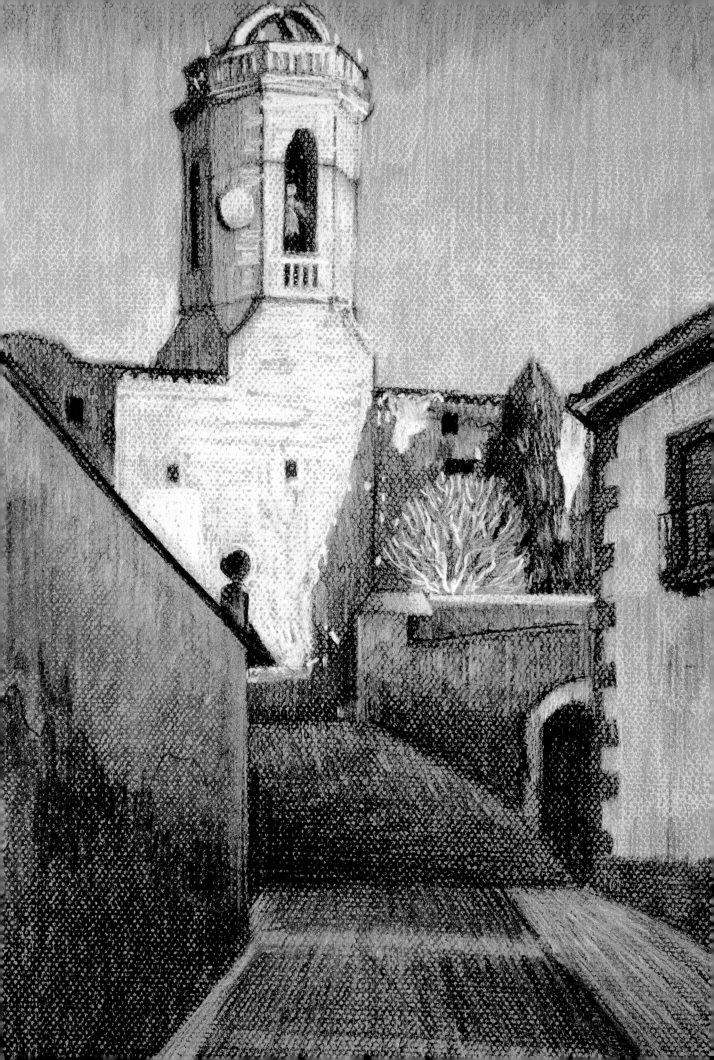

COMPATIBLE MEDIA

Introduction

The Spanish word *dibujo*, for "drawing," derives from the word *boj*, which refers to the small tree with hard, yellowish, and velvety wood that, after being turned into charcoal, is used to write or mark on a hard support. This is without a doubt the predecessor of the charcoal stick. This significant fact directly relates the charcoal stick to the origins of artistic representation. Therefore, it is not farfetched to think that the first drawing tools were charcoal sticks or different pigments crushed and bound with glue or wax (chalk and crayons).

In this hierarchy, charcoal has always occupied a place of distinction. As a result of its qualities, charcoal has remained an excellent medium for beginners. It can be used broadly without one getting lost in the details, and its marks are not permanent, making it easy to erase and correct with a finger or a rag. Other properties of charcoal have also long been recognized; its suitability for shading, and the dark black that can be achieved, allow the artist to abandon line drawing and to concentrate on *adumbrare,* that is, in creating a drawing with delicate graded and modeled tones. Charcoal played a vital role in the success of monochromatic drawing, which in the hands of Pisanello and Gentiale de Fabriano during the Renaissance period became a medium in its own right. The place of monochromatic drawing was assured when sanguine crayon became popular during the fifteenth and sixteenth centuries.

It did not take long for chalks, which are made of natural pigments held together with glue binder, to become a vital tool for the artists of the time. Even though they produced similar results to those of charcoal, they did not replace it. Because they were hard, chalks were used more often to make thin lines than for broad and heavy shading. As a result of the incorporation of new pigments, chalks became available in a traditional range of colors, which consisted of black, white, gray, and earth tones (sepia, sanguine, bister, and ocher). Artists became fascinated by this limited selection of colors because combining them in a single work gave the drawing a unique warmth and softness. These colors became especially invaluable for portraits and studies of nudes. In this sense, chalks became the predecessors of color drawing and were the transition from representations made in black and white to the colors of pastels and color pencils. With time, charcoal and chalk have merged. In many aspects they share the same plastic techniques and resources, making them perfectly compatible.

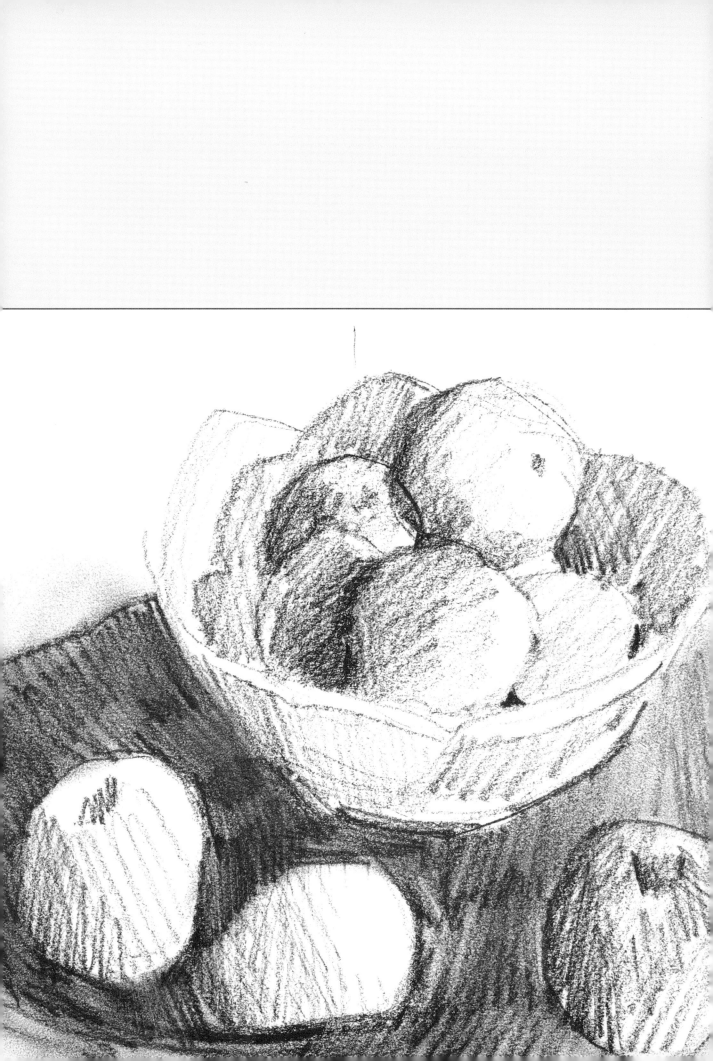

DRY TECHNIQUES

DRY TECHNIQUES

Charcoal, chalk, and sanguine crayon are dry to the touch and have a covering power that makes a strong impression on the surface of the paper. Because they are made of fine particles, they are applied to the paper by friction and can produce a great variety of lines, gradations, and blends. These media have a greater affinity for drawing based on a tonal approach rather than on a strictly linear one, and can produce outstanding results. Their versatility makes them indispensable as tools for the serious artist. To maximize performance, however, it is important to understand the possibilities of their line, their application, their combination, and the various effects that can be achieved using them.

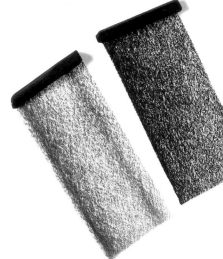

Compressed charcoal sticks produce darker and more textured shading than conventional charcoal.

The MATERIALS

Types and qualities of MATERIALS

It is important to learn about the different varieties and qualities of charcoal, sanguine crayon, and chalk in order to understand how each tool performs and to know how to fully take advantage of them. Even though each provides a different artistic result, no one of them is intrinsically superior to the others.

Charcoal

This is a form of thin, carbonized twig, available in different thicknesses. Charcoal is a very versatile and extremely pure and direct medium, which can afford the artist great creative possibilities, making it the most appropriate medium for learning to draw.

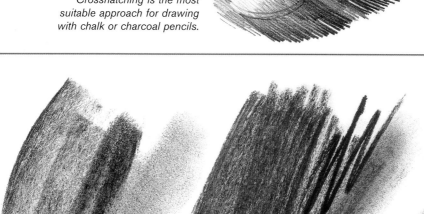

Crosshatching is the most suitable approach for drawing with chalk or charcoal pencils.

Compressed Charcoal

This is made from the pigment of black smoke mixed with a binding agent and compressed into round or square sticks. It is handled in the same way as traditional charcoal; however, the resulting lines are deep black.

Chalk and Charcoal Pencils

These are pencils with charcoal or chalk leads lightly bound with an agglutinant to give them consistency and make them suitable for sharpening. They produce their best results on small format work. Their most notable downside is that they cannot be rubbed easily, and they have a tendency to break.

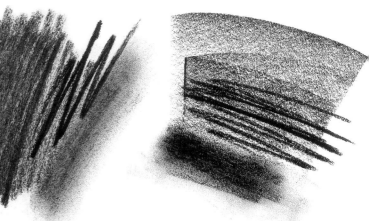

Dragging the stick of charcoal on the paper produces light and covering lines. Charcoal can be easily blended, but the downside is that it makes the line very unstable.

The stick of compressed charcoal makes a darker and more textured line. It is not as easy to blend and is more difficult to erase.

Chalk produces a coarser line. Because it is harder and darker, it is always more precise; however, it is also much harder to correct.

We can work chalk pigment with a cotton rag.

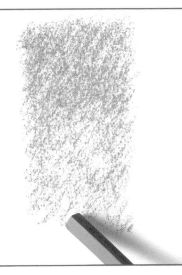

Artists commonly combine two or three different color chalks in the same drawing.

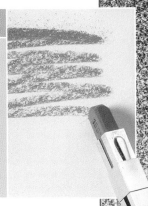

Advice

A square chalk holder or extender can be very useful for using up small pieces. It provides a good grip on the chalk and good control of the lines.

Charcoal and Chalk Powder

Some artists use only charcoal and chalk in powder form to work with shading. Both are applied by rubbing with a cotton rag. This approach is very useful when a drawing requires a high degree of subtlety.

Chalks

Chalks are bars made of hard pigment bound with an agglutinant. They can produce greater tonal variations and darker blacks than charcoal. Their line is more stable, and if needed they can produce a more delicate look than charcoal.

Sanguine

The term "sanguine" denotes a crayon whose color can range between iron oxide and terracotta red. Among the crayons, this color stands out for its unique personality, which is marked by its tonal warmth and the beauty of its effect.

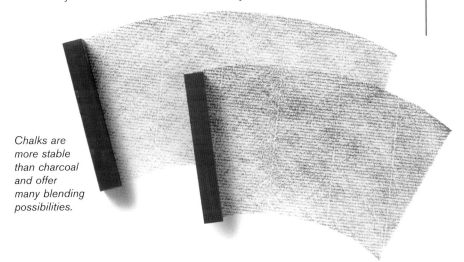

Chalks are more stable than charcoal and offer many blending possibilities.

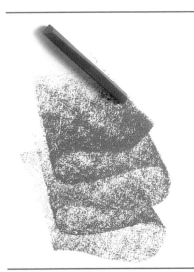

A stick of sanguine or chalk produces a more textured look, yet it can provide great tonal ranges.

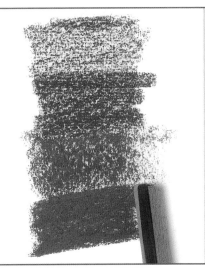

Working gently with the tip of the stick can produce very light shading that can then be blended until all the lines are totally eliminated.

It is important to practice shading with chalks of different hardness. Here are three examples, ranging from the hardest chalk, at the top, to the softest, at the bottom.

POSSIBILITIES OF CHALK

Drawing
LINES

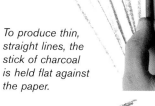

To produce thin, straight lines, the stick of charcoal is held flat against the paper.

Making lines is the most common way of drawing. This method is vital for describing contours and the shape of the objects that are being drawn. The speed of the line, the grip, and the way the stick is handled all have an impact on the type of line produced. This knowledge can be applied to any drawing to create a wide range of treatments and effects.

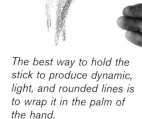

The best way to hold the stick to produce dynamic, light, and rounded lines is to wrap it in the palm of the hand.

Controlling the Wrist

It is very important to experiment with the different possible motions and to control the movements of the wrist and the fingers to create lines that are linear, curved, broken, and with practice, even artistic. In the latter case, it is vital to hold the charcoal stick so that it is under complete control.

Straight and Curved Lines

It is difficult to draw a thin, straight line with a piece of charcoal or chalk, unless it has a sharp point. A way to make one is by dragging the stick lengthwise on the surface of the paper. The resulting line will be narrow and firm as it is almost impossible for the stick to wobble; its own momentum serves as a guide. If the stick is held

pencil-like wrapped inside the palm of the hand, we can draw quick, firm lines guided by the hand's movement to create curved and continuous lines, drawn without lifting the stick from the paper.

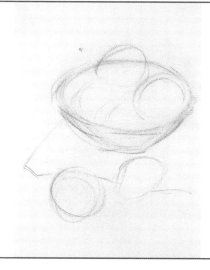

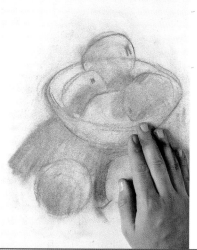

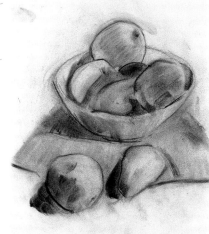

This method consists of repeatedly drawing and erasing with the charcoal. First, we highlight the basic features of the drawing, and then we erase them with the hand.

We shade over the previous layer and we erase again with the hand. In this way the image disappears and resurfaces several times during the drawing process.

A drawing such as this one is based on the aggregate of the erased layers, each one an addition to the previous ones.

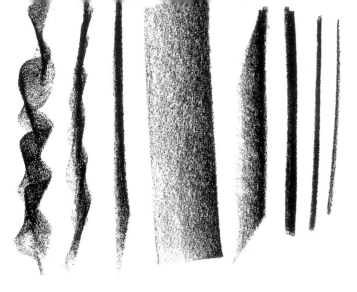

It is important to experiment with different kinds of line on a separate piece of paper using charcoal and varying the angle, the pressure, and the rhythm of the line.

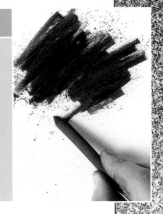

A Variety of Lines

A great variety of lines can be created with a stick of chalk or charcoal. At the beginning, the lines are as wide as the thickness of the stick, and they are vulnerable to the natural movement of a free-hand drawing. However, it is possible to create small variations, depending on the degree of inclination of the stick. Therefore, a flat point will produce heavy lines, whereas a sharp or diagonal point will produce thin lines.

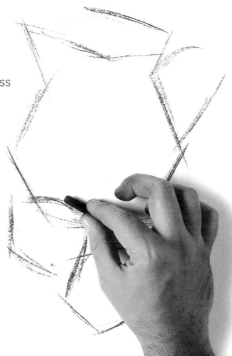

Direction of the Lines

Holding the charcoal stick between the thumb and index fingers and sliding it downwards on the paper can produce controlled and even lines, although the charcoal will have a tendency to break due to the applied pressure. On the other hand, if the charcoal is moved in an upward direction, the line will be stronger and deeper, which gives the drawing a solid appearance. However, it is a little more difficult to control the firmness of the line with the latter approach.

With charcoal, mastery of line is required in the preliminary phases of the drawing.

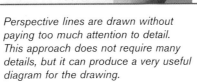

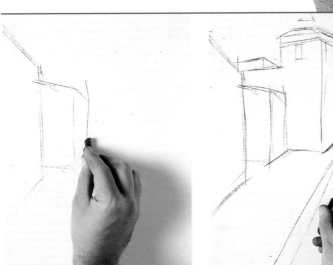

BLOCKING-IN WITH STRAIGHT LINES

To block-in a model using straight lines, the charcoal should be held flat and lengthwise. Dragging it will produce thin lines that are easy to control.

Perspective lines are drawn without paying too much attention to detail. This approach does not require many details, but it can produce a very useful diagram for the drawing.

The only thing left to do is to go over the main lines. This method of drawing makes it possible to create very decisive and firm lines in addition to making them very straight.

11

*Working with the flat side
of the stick speeds up the
shading process.*

*The technique of
shading with the flat
side of the charcoal
stick makes it possible
to synthesize and
solidify the structure of
the shapes.*

SHADING *techniques with a stick*

Line used by itself is a beautiful approach to drawing, but the array of possibilities widens when it is combined with shading. Shading includes all the tonal elements present in a drawing and consists of working the surfaces in such way as they appear to be three-dimensional and to have volume.

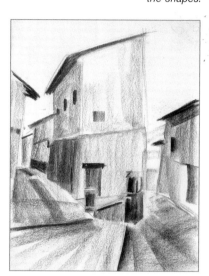

The Most Comfortable Medium

Charcoal is the most comfortable medium for shading and for creating tonal values. A charcoal drawing is done with very few lines, which are combined with minimum shading, strategically distributed, by working with the side of the stick, erasing, blending, and shading again.

Effects and Possibilities of Chalk

As with charcoal, the entire length of the chalk stick can be used for drawing. In addition, the line can be altered and blended very easily. Chalks are soft enough to be blended by rubbing with a finger, a cloth, or a blending stick. They can even be blended by superimposing layers of color, in such way that the lower layer will show through.

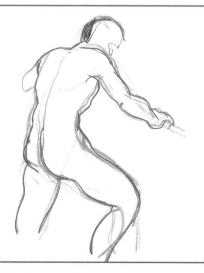

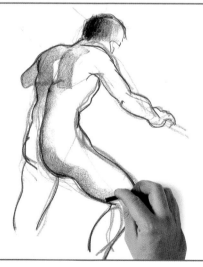

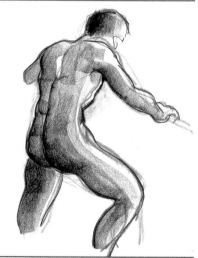

The best way of using the stick is to continue the line as long as possible before lifting it. Here are some examples shown on the sketch of a human figure.

With a piece of chalk we begin shading from the shoulders down to the buttocks without interrupting the line.

Finishing the back with new shading, we extend and vary the pressure of the line to produce greater color intensity by using darker tones or heavier accents.

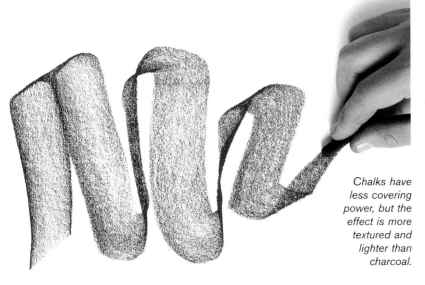

Chalks have less covering power, but the effect is more textured and lighter than charcoal.

Breaking the Stick

It is not a good idea to use the whole charcoal or chalk stick for shading. It is better to break it up into smaller pieces that are easier to handle. Two to two and one-quarter inches (5 or 6 cm) is a good width.

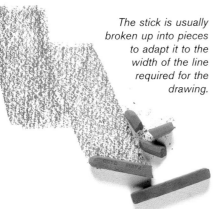

The stick is usually broken up into pieces to adapt it to the width of the line required for the drawing.

Large Shading Strokes

Large shading strokes, as wide as the length of the stick, can be applied by using the charcoal or chalk stick's flat side on the paper. To begin shading, the side of the bar is moved sideways while applying pressure on the paper. Without stopping, we change directions, going from drawing lines sideways to drawing vertical lines. The thickness of the line can be changed by simply rotating the piece of stick and adjusting the amount of surface that is in contact with the paper, according to the direction of the line. Adjusting the pressure controls the intensity of the shading.

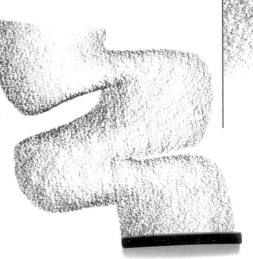

If we change the angle of the stick, the thickness of the line will change. This way, we will be able to customize the line according to our needs.

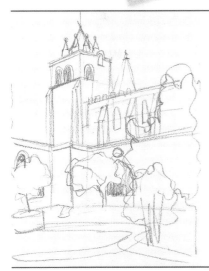

SHADING WITH THE FLAT SIDE OF THE STICK

We begin sketching with the tip of the sanguine crayon, applying very little pressure. We concentrate on the building's perspective and disregard the surrounding vegetation.

The main shaded areas of the building are applied by drawing with the flat side of the crayon. A second layer of deeper shading is added using a smaller piece.

We treat the vegetation of the foreground the same way, using the crayon's flat side. The crayon is handled with rhythmic and overlapping movements to recreate the texture of the foliage.

Effects with
a PENCIL

Charcoal and chalk pencils are good for line drawings, similar to those done with graphite pencils, although the lines are darker. They produce good results when working on quick sketches and small pieces that require more lines than shading.

The Final Steps of a Drawing

Charcoal and chalk pencils are used in combination with sticks, generally during the final phases of a piece: to touch up contour lines, to redraw the shapes of some objects, or to draw some textures with more precision.

The Pencil Based on Its Hardness

Pencils are cleaner to handle and easier to control than sticks. The lead has a harder and more abrasive consistency. They are classified as extra-soft, soft, medium, and hard. The line produced by hard pencils is more defined than those drawn with softer pencils, but it is also harder to erase.

Charcoal pencils produce completely linear drawings with well-defined outlines.

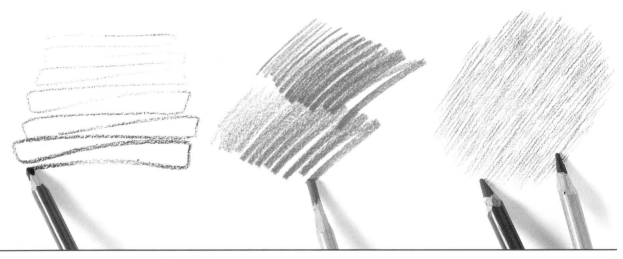

We can modulate the line while drawing. This requires changing the pressure during the process to create a line that has different intensities.

Modulating the crosshatching can also be achieved by gradually increasing the pressure of the line while a new one is being added, producing a certain gradation effect.

Pencils produce a much more subtle effect than sticks. This makes blending lines of different colors easier when creating uniform fields.

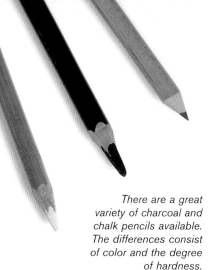

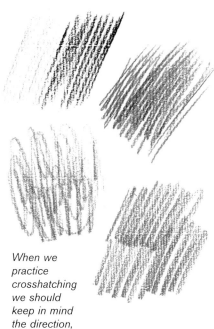

There are a great variety of charcoal and chalk pencils available. The differences consist of color and the degree of hardness.

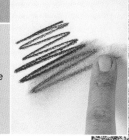

Advice

Lines drawn with charcoal pencils can be blended as well, although they are more difficult to manipulate than those made with a stick.

Shading with Crosshatching

When it comes to shading, pencil lines are not as soft and perfect looking as those done with a stick, but the results are more spontaneous, looser, and more energetic, typical characteristics of sketches and studies. The most common way of shading with a pencil is to create several tones with crosshatching. For the lighter tones the tip of the pencil should be sharp, for the darker and more covering ones, the tip should be worn or else the pencil could be slightly tipped to the side.

When we practice crosshatching we should keep in mind the direction, thickness, and intensity of the line.

Profile Drawing

One of the best ways to learn how to work with charcoal and chalk pencils is to draw profiles. With a sharp pencil, draw the contours of various objects using one continuous line. Vary the pressure on the pencil and angle the tip to change the intensity and thickness of the line.

Shading with charcoal or chalk pencils calls for the use of crosshatching.

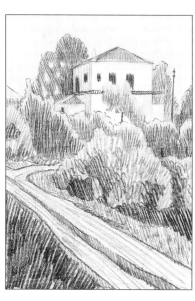

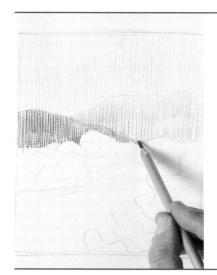

The best way to approach a tonal sketch with a charcoal pencil is as follows: First, light crosshatching is applied to the background with the hardest pencil.

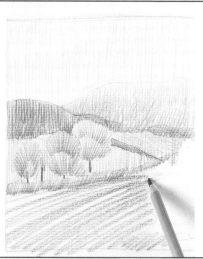

Using the same pencil, we apply more pressure to sketch the middle ground. The trees, the rows of vegetables, and the lines on the ground should be clearly defined.

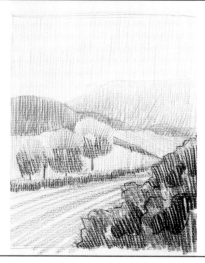

The vegetation in the foreground is drawn with a soft charcoal pencil using new crosshatching that contrasts with the background.

SHADING WITH PENCILS

15

TONAL
techniques

It is important to learn to associate the intensity of the shadows in any model with the various tones of gray that the charcoal is able to produce.

A drawing can be done with lines, or it can also be done exclusively with shading. It is important to study the incidence of light in all areas so the different visual planes can be identified, highlighting the sense of volume in the drawing.

A Model with Few Tones

The position and form of the shadows depend on the placement and intensity of the light source that illuminates the model. Even when there is a wide range of tones present, it is important to reduce them into three categories according to their tonal predominance: light, intermediate, and dark. From here on we will practice drawing with these three values. As we gain confidence, we will add new gradations to the previous ones.

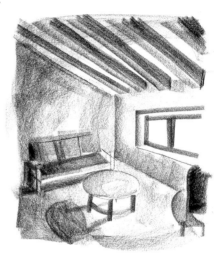

Quick sketch of an interior executed with only three tones of shading.

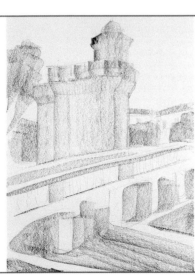

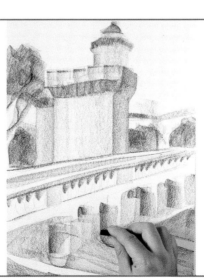 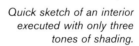

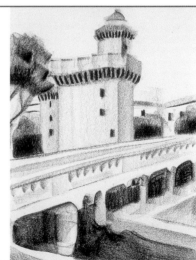

When shading with a stick, it is important to begin by differentiating the dark areas from the light ones using a very light first approach, executed with the side of the stick.

We apply new shading over the previous layer to define the medium intensity shadows, which makes it possible to establish a gradual transition between light and shadow.

More pressure is applied with the stick to draw the last layer of shading, which represents the areas of the model that are darker and have greater contrast.

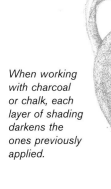

When working with charcoal or chalk, each layer of shading darkens the ones previously applied.

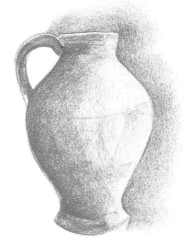

Advice

The outline or profile of a drawing created with shading is the meeting between the lighter and the darker tones, with no transition in between.

Tonal Gradations with Charcoal

Even though charcoal can be dirty and difficult to preserve due to its powdery consistency, its outstanding ability to produce tonal gradations makes it worth investing some time in learning the technique. The main thing to keep in mind when working on tonal techniques with this medium is to apply darker shades than required because the final tone becomes much lighter after blending.

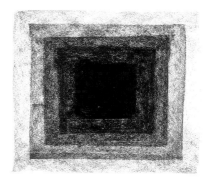

A Tonal Square with Chalk

Since they contain greater amounts of binding agent than charcoal, chalks stick better to the paper, and therefore it is not necessary to apply darker than normal shading. To practice with tonal scales using chalk, it is a good idea to draw a tonal box such as the one shown here. Each band should be increasingly darker than the previous one to create a smooth transition from light to darkness.

Superimposing Layers

A tone can be darkened by adding a new layer of shading over it. With this approach to layering, it is important to keep in mind the paper's saturation. It is a good idea to test the degree of saturation on a separate piece of paper and to establish the system of values in reference to the darkest tone.

Each tone in the box is created by increasing the pressure on the stick.

TONAL RANGES

In subjects with a light tonal range, the white of the paper can be the main tone, which can be combined with black and intermediate shades.

In subjects with a medium tonal range, the dominant tone is intermediate. In this case, gray covers everything and occupies more surface.

Black is dominant in subjects with a low tonal range. The brightness of the white paper is greatly reduced, and the image conveys more power and is more expressive.

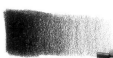

To apply a gradation, we begin by shading the entire surface, pressing hard on the stick.

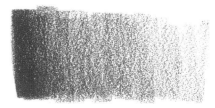

As we move along the surface we gradually decrease the pressure, which will make the tone of the shading lighter.

GRADATIONS,
modeling, and chiaroscuro

If we create the correct tonal value with gradations, by lightly modeling the forms, we will be able to describe the entire volume of the model. When modeling is approached through very heavy gradations, with strong contrasts between light and shadows, the resulting effect will be chiaroscuro.

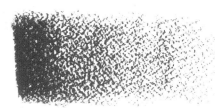

A gradation depends, in great part, on the texture of the paper. Gradations look smooth on fine-grain paper.

Gradations

Gradations can be easily created with charcoal by simply placing the stick flat on the paper and dragging it up and down on the surface that we wish to cover. We begin by applying a very light tone that is darkened with each passage. Most gradations made with a stick look very diffused and airy if the paper has a fine grain, and grainy and broken if the paper is textured. Whether very diffused or grainy, lines should never be visible in a gradation.

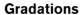

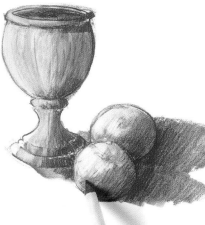

On heavily textured paper the pigment sticks to the paper's raised surface and the result looks grainier.

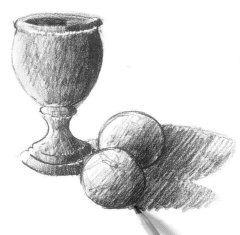

We will show how to apply a graduated effect using an actual object so we can explain how the volume is represented. First, we draw the figure with a brown chalk pencil.

We shade one side of each object in such way that the gradation becomes lighter as we approach the lighted area.

We consolidate the gradated areas with a blending stick. The shadows become darker and the transition to the light area more gradual.

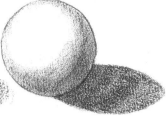

Sphere created with the stick in the flat position, without modeling.

Sphere modeled by shading with the fingers to create smooth transitions.

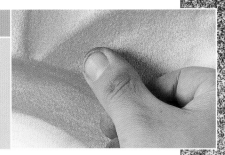

Modeling with strong contrasts between lighted areas and shaded areas, known as chiaroscuro.

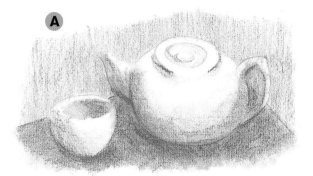

Modeling and Chiaroscuro

Once we finish shading with the stick, the tones are blended (with your fingers, a blending stick, or a rag) by rubbing gently until a smooth transition between tones is created, making an imperceptible gradation. The gradated tone, gently blended with the fingertip to eliminate any visible lines, is the foundation of this effect. The chiaroscuro is created by emphasizing the volume with strong contrasts between lighted areas and shaded ones. For chiaroscuro, the modeled effect is achieved by using more shaded contrasts and fewer lighted areas, but with brighter highlights.

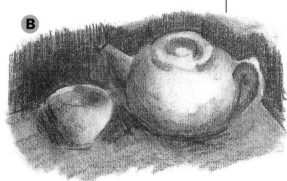

Here we can see the difference between a modeled and shaded drawing (A) and one created using the chiaroscuro technique (B).

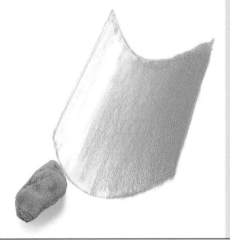

This illustration shows how to represent the light on a rounded surface using sanguine crayon. We begin by applying a gradation with the flat side.

We blend the gradation with a blending stick to create a progressive transition between tones.

With a soft eraser we define the outlines and create a narrow white band on the left side to represent the area with the most light.

MODELING FLAT SHADOWS

Blending lightens shaded areas and makes them delicate and smooth.

The texture of the paper creates coarse-looking shading that contradicts the smooth texture of the cylinder.

Blending
and SFUMATO

Rubbing consists of spreading and removing color with the intention of forming a gradation or reducing the tone. Blending, or sfumato, is more generalized, and its use is more common for minimizing contrasts between tones that are far apart. Both techniques are closely related.

The Rubbing Effect

A layer of pigment applied on the paper can be modified by rubbing (with the hand, a rag, a blending stick . . .) to reduce or to spread it. Rubbing allows the integration of the shaded surfaces by eliminating any white areas. Although this is a very commonly used technique in modeling, it is important not to overuse rubbing because it can produce a dull effect.

Sfumato

The Italian term *sfumato,* "to smear" or "blur," refers to the creation of very subtle and fluid tonal gradations and to various blurring effects that allow objects to be described without making use of lines or contours. This means that any traces of lines are blended until they are imperceptible and that the model is represented with loose, blurry, and out of focus contours creating very atmospheric effects.

Blending effect created with the fingers on a landscape done with charcoal.

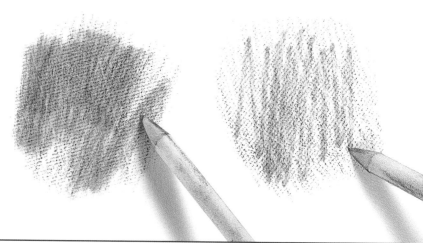

For large areas, long and descending strokes are applied horizontally by placing the blending stick flat on the paper.

For overall sfumato, the blending stick can be held at an angle so the entire tip is used and moved from top to bottom repeatedly.

The point of the blending stick is used to soften the contours and to apply delicate touch-ups.

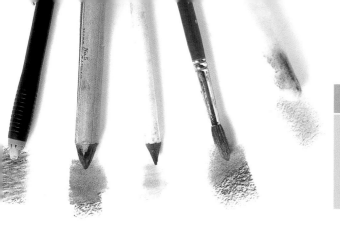

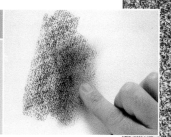

Shown here are some of the most commonly used tools for blending shaded drawings, other than the hand itself: eraser in a holder, large and medium blending sticks, brush, and a piece of cotton swab.

Blending with Charcoal and Chalk

Shading with charcoal usually calls for the blending technique because it is very difficult to go from less to more by working only with lines. Blending charcoal drawings must be approached gently to maintain the texture, the energy, and the expressivity of the lines.

The dense and rich pigment that characterizes chalk produces light and airy effects when manipulated with the blending stick. However, this pigment is not as delicate and volatile as that of charcoal.

The results of blending with chalk are more intense and cover the white of the paper much more easily.

Shown here are some blending effects created with various techniques and tools: area spread with the tip of a blending stick (A), marks created with the tip of a dirty blending stick (B), area blended with the flat side of the blending stick (C), charcoal blended with the finger (D), area blended with an eraser (E), area blended with a cotton swab (F).

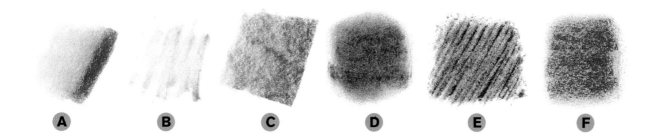

A **B** **C** **D** **E** **F**

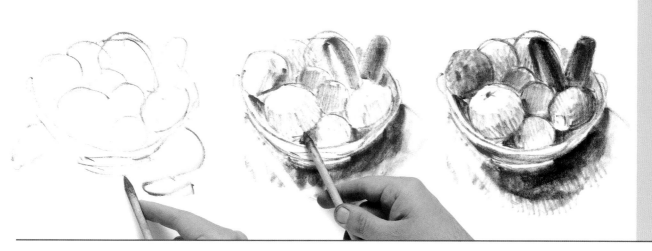

Blending sticks can also be used as drawing tools. The tip of the blending stick is dipped into brown chalk powder and used to draw on the paper.

For shading, we use the tip of the blending stick placed at an angle. The resulting tone is very light. More pigment is added for darker areas of shading.

The shaded area is darkened gradually with layers of color. Darker or lighter tones are produced depending on the amount of pigment applied.

21

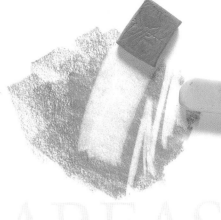

It is a good idea to have different shapes and kinds of eraser handy for creating a variety of effects when drawing with charcoal or chalk.

ERASING
and WHITE AREAS

Erasing and lightening are techniques used to reduce or to eliminate the shaded areas of a drawing, either by exposing the underlying white surface of the paper or by covering an area previously worked with dark tones with white chalk.

Eraser: An Essential Tool

A kneaded eraser is an essential tool, not only for correcting mistakes, but also for restoring the color of the paper after drawing on it. A kneaded eraser is normally used for drawings done in charcoal and chalk.

Lightening with a Rag

Removing charcoal is very easy because charcoal provides only superficial coverage, and sometimes using an eraser is not necessary. Often, a clean cotton rag is sufficient to remove charcoal and create a very light tone.

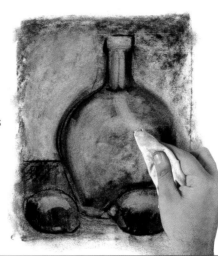

A cotton rag is commonly used to lighten shaded tones in drawings done with charcoal.

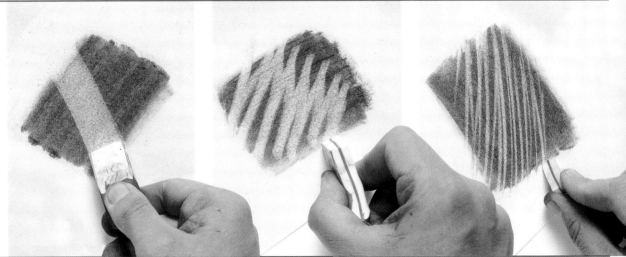

A variety of effects can be easily created with an eraser. Placing the eraser flat on the paper produces wide bands.

We can create narrower bands that are lighter and have more contrast by using the tip of the eraser.

If we cut the eraser to form a sharp tip, we can create thin lines. Small pieces are ideal for erasing small areas.

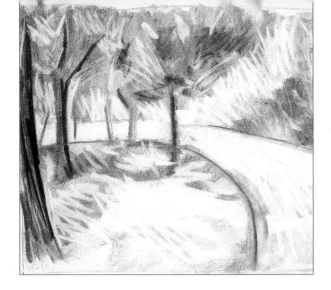

When the surface of the paper is completely shaded, erasures help highlight the texture of the theme.

Advice

An eraser pencil is very useful for drawing by erasing. It is also very suitable for making lines and defining details.

How to Use an Eraser

When erasing, we should alternately press and lift the flexible eraser from the paper. For minimizing a tone, we simply touch the paper gently, as if caressing it, by placing the flat side over the desired area. When the eraser is very dirty, we can knead it until the dirty part is no longer visible.

The qualities of white chalk can be better appreciated on color paper.

Adding Light with Chalk

White chalk is a very useful tool for representing light in a drawing done in dark tones or on color paper. The white areas created by the chalk can be soft and diffused or sharp and contrasted, creating a very strong point of light. On an object, the brightest and shiniest areas represent the points of maximum light. It is here where highlights should be created with white chalk rather than by erasing.

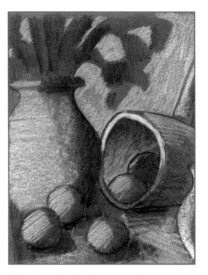

The most highly illuminated areas of a drawing are represented by pressing hard with the tip of a stick of white chalk.

THREE TYPES OF WHITES

Let us compare these three types of whites. We begin by wiping off the charcoal with a cotton rag. The result does not have much contrast and the edges are very diffused.

The effect of the paper is greater if we use an eraser to remove the charcoal. The edges are cleaner and the contrast is more pronounced.

Highlights with white chalk are very effective. It can produce a wide range of white tones and can create the greatest contrast against the black charcoal.

23

DRAWING *with the* HANDS

The most direct and effective way to apply, blend, and model shading is with the fingers or with the side of the hand. By gently scraping the sanguine crayon, we will get a fine powder that can be used for drawing with the hands. If you do not wish to do this yourself, you can purchase sanguine pigment already in powder form at any art supply store. We will show you how to work with it.

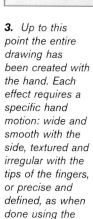

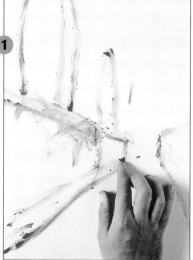

1. Do not be afraid of getting the tips of your fingers dirty with the fine powder. We will use them to draw the shapes that describe the hedges and the cypresses. We change fingers according to the width of the lines.

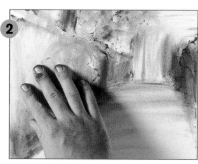

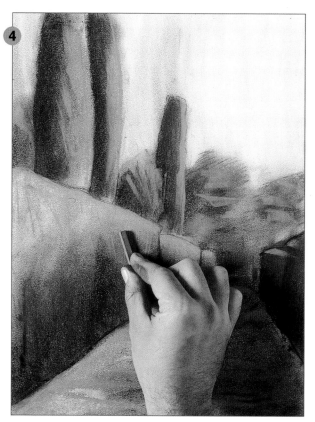

2. We rub more vigorously with the hand open to shade the previously drawn shapes. To make the tones darker we only need to dip the fingers in the powder again, applying new shadows over and over again.

3. Up to this point the entire drawing has been created with the hand. Each effect requires a specific hand motion: wide and smooth with the side, textured and irregular with the tips of the fingers, or precise and defined, as when done using the tip of the little finger.

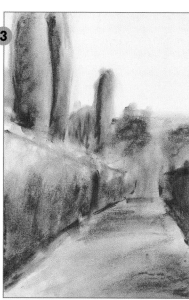

4. If desired, the drawing can be complemented by lightly shading with black chalk in the areas of shadow. Ocher can be used in the illuminated areas. This gives a sense of volume to the work.

USING *the* TEXTURE *of the* PAPER

One of the most important characteristics of charcoal is its adaptability to the texture or grain of the paper. If we draw on heavily textured paper, the line created with the stick of charcoal will have a granulated effect, a uniform mid-tone that adds interest to the drawing.

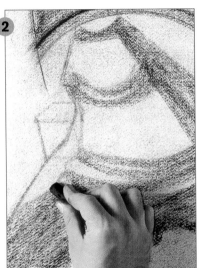

1. We begin drawing on textured paper the same way we would on any other type of surface. The shapes and contours of the main lines of the object are drawn with the tip of the charcoal stick.

2. The shading phase is done with the stick held the long way. Here, the texture of the paper breaks up the long strokes, giving them a very spontaneous, less solid, and compact look.

3. The light or darkness of the drawing depends on the pressure applied on the stick. The side and not the tip should be used for shading; otherwise, we would cover the texture of the paper completely.

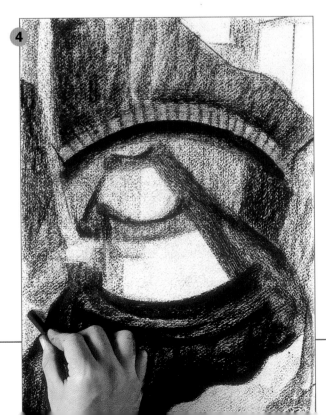

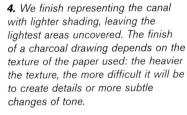

4. We finish representing the canal with lighter shading, leaving the lightest areas uncovered. The finish of a charcoal drawing depends on the texture of the paper used: the heavier the texture, the more difficult it will be to create details or more subtle changes of tone.

COLOR
combinations

In drawing, chalks, and sanguine among them, are considered the color providers. The combination of basic colors (black, white, sepia or bister, sanguine, and in some cases ocher) is more than enough to make sketches, studies, and other works that require color impressions.

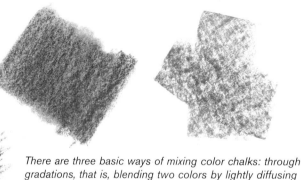

There are three basic ways of mixing color chalks: through gradations, that is, blending two colors by lightly diffusing them; layering several shades of color; and by combining various color lines, making them look superimposed.

Very Harmonious Colors

The range of chalks available nowadays is very wide, but traditionally it was reduced to black and white chalk, reserved for creating light and shadow in drawings, and to the earth tones: sepia, bister, ocher, and sanguine. These tones are very harmonious and work together perfectly. Different color chalks work very well together, and they can be blended and combined the same way charcoal is. Therefore, working with tonal values and shades is very similar to working with monochromatic drawings.

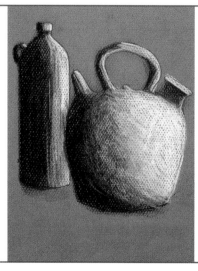

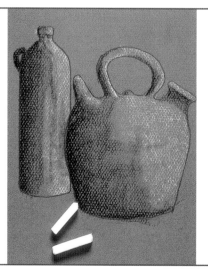

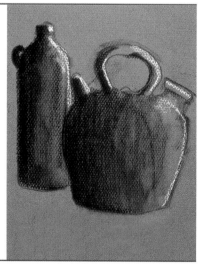

When a drawing has a generous amount of shading, we can create contrast by highlighting large areas with white chalk, using the tip of the stick.

White and black chalks applied very lightly, with the flat side of the stick, can soften light to shade transitions. They can also provide atmosphere and a sense of volume.

If the drawing requires greater control of the shadows, more localized and selective highlights can be applied, and only in those areas where they are strictly needed.

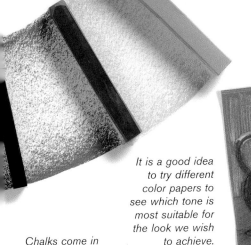

Chalks come in a wide range of hardness and color.

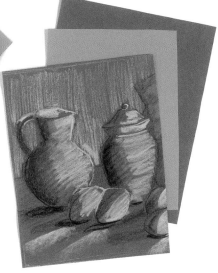

It is a good idea to try different color papers to see which tone is most suitable for the look we wish to achieve.

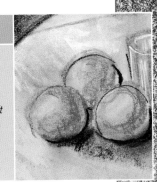

Advice

If we choose color paper, we must see it as one more color to use. Areas left uncovered will correspond to the tone of the paper.

Color Contrasts

Tonal values are also very important; in fact, contrast between colors is another way of differentiating between light and dark areas. The general rule for the distribution of colors is as follows: dark areas (with black chalk), light areas (with white chalk), medium light tones (with ocher or sanguine chalk), and medium dark tones (with bister or sepia chalk).

Color Paper

Color chalks produce better results on medium-tone papers than on white. Forms and tones can be created quickly because any color chalk, brown, black, ocher, or sanguine will produce equally acceptable results. Light ocher, light sienna, green or blue grays, and cream colors are frequently used.

The illuminated areas of the model are represented with white, light gray, and ocher.

Medium-tone shading is done with sanguine, medium gray, and ocher.

Darker shading is drawn with black, dark gray, or brown (bister or sepia).

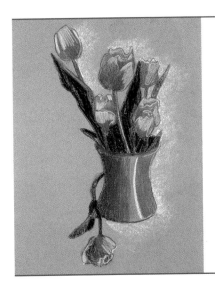

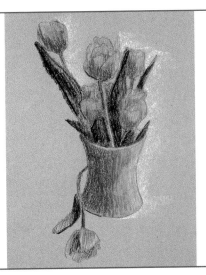

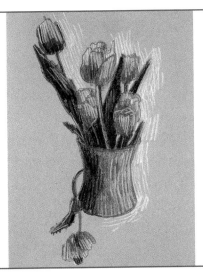

We will explore three ways of combining colors. Here, the colors have hardly been mixed, black chalk defines the shadows, sanguine the flowers and the vase, and white the highlights.

With this technique the three colors are mixed with light shading to create a more atmospheric treatment with less contrast than in the previous case.

We can combine the three colors by drawing with pencils of the same color. The mixtures here are achieved by introducing crosshatching. The result is very expressive.

DRAWING WITH THREE COLORS

27

STUDIES *for a* LANDSCAPE

Charcoal can be used for drawing landscapes just as it can be used for any other theme. However, there are some differences in the treatment that are worth addressing. Here we see examples of studies that range from quick sketches, done in no more than two minutes, to ones that may require up to five minutes.

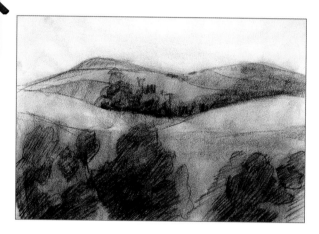

The first areas of color are applied with vine charcoal. The tree masses in the foreground and the outline of the mountains are touched up with a charcoal pencil. The atmosphere, the treatment of the vegetation, and the terrain cannot be worked with systematic detail, instead a generalized approach is required.

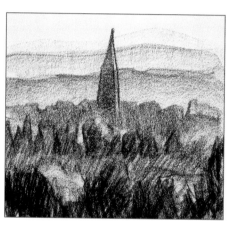

Chalk produces darker shading. If we use heavily textured paper, the effect achieved is more atmospheric. In landscapes such as this one, it is a good idea to define the different planes, reducing the intensity of the shading as we move farther away.

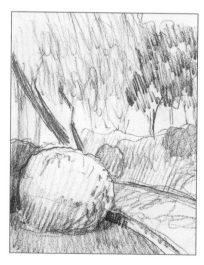

Trees are excellent subjects for drawing because their complex shapes and their movement, which is continuous at times, are difficult to capture. It is an ideal opportunity for practicing how to do a quick sketch with a chalk pencil, a linear work without blending.

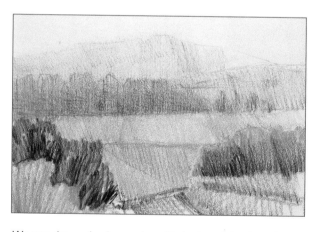

We can draw a landscape from life by translating its colors into two values: ocher (chalk) and black (charcoal). We add light shading created with charcoal over that, defining the different planes. The foliage of the tree is a medium gray; the grass is depicted with a light gray.

DRAWING *with* WHITE CHALK

It is important to explore the possibilities of drawing using only white chalk. To do this, it is indispensable to select a color paper that will provide an appropriate background for the chalk. With a dark color paper, the light areas must be worked progressively. This is neither easier nor more difficult than doing it conventionally, it is just done the opposite way.

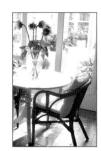

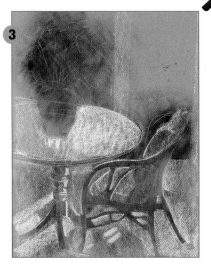

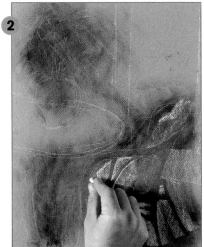

1. The space occupied by the chair, the lower part of the table, and the vase are identified on the medium-tone gray paper with blocks of color done in charcoal. A white chalk pencil is used to sketch the spontaneous and quick outline.

2. We create the first white areas with the side of the stick, producing wide blocks. If we show the areas of light around the chair, the outlines of the objects will begin to emerge.

3. The larger areas of the tabletop and the floor are treated as if they were gradations. The window frame is painted with the side of a piece of chalk.

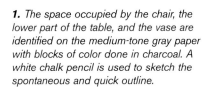

4. The illuminated background surrounding the vase is drawn with the tip of the stick. The outlines of the flowers emerge in contrast. With a brighter white we lighten the water inside the crystal vase.

5. The drawing changes if we use chalk in stick or in pencil form. The first is more suitable for creating areas of color; the pencil is better for crosshatching.

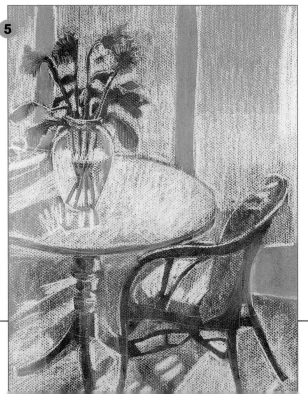

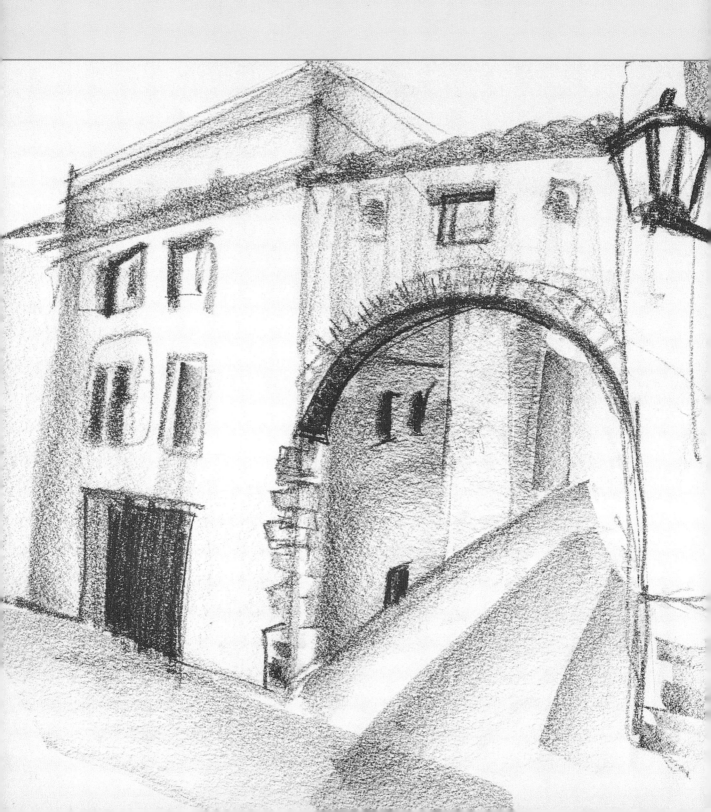

EXERCISES
PRACTICAL EXERCISES

B efore deciding whether a drawing will be done in charcoal, sanguine, and/or chalk, it is important to think about the treatment and the desired style, the intention of the line, the requirements of the subject matter, the intensity of the shading . . . Then, depending on the results that we wish to achieve, we proceed with the most appropriate medium, the one that will allow us to produce a specific effect with greater ease. Therefore, in this section, which is practical in its entirety, we will test the possibilities and limitations of each medium and explore how selecting one technique or the other will determine the final result of the work.

SHADING *with* CHARCOAL

SHADING *with* CHARCOAL

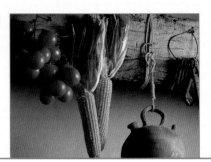

As a first experiment, we look for a still life with areas of light and shadow that are clearly defined, a still life without depth, with large and simple shapes that can be drawn with wide strokes. The first exercise is shown unfinished because the main goal is to observe how the first forms, the first overall shadows of a drawing that can later be finished, are applied.

Before we begin drawing, the background must be properly prepared. This is done by reducing and blending the initial shadows by simply rubbing the surface, as if caressing it with the tips of the fingers.

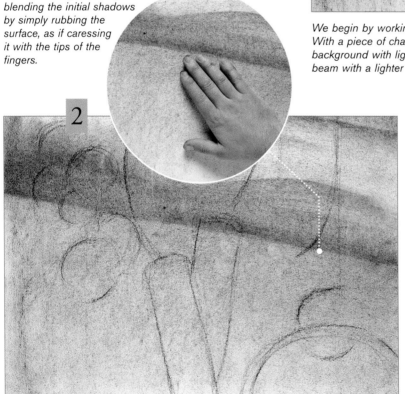

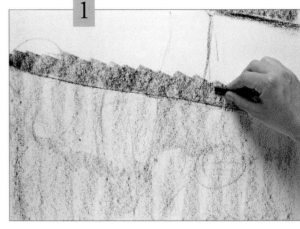

We begin by working on the composition's background. With a piece of charcoal held horizontally, we cover the background with light gray. We apply shading to the beam with a lighter gray.

Advice

In general, the flat side of the stick is used for shading, whereas the tip is more suitable for sketching and for outlining objects.

We blend the background shading with the palm of the hand. Then we sketch the shape of each object over the blended surface with the tip of the stick. Just a few curves and circles are sufficient to block in the objects.

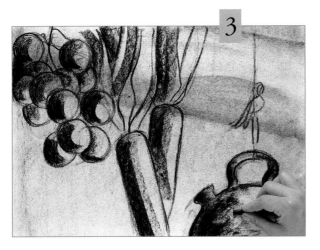

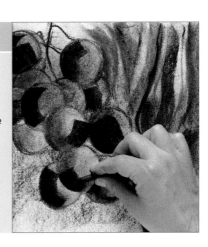

3

Advice

Do not hesitate to press the charcoal stick hard on the paper to produce strong black colors. Rubbing will reduce their intensity and the colors will blend into the drawing.

The first shadows are applied quite liberally with the flat side of the charcoal. We extend the dark gray shadows over each object, shading only the side that is away from the source of light.

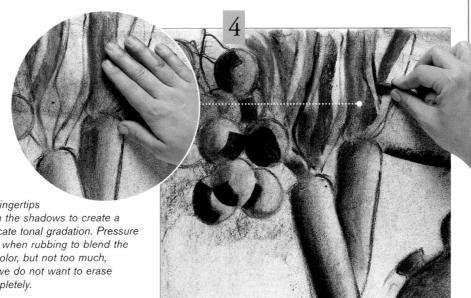

4

With the fingertips we lighten the shadows to create a more delicate tonal gradation. Pressure is applied when rubbing to blend the areas of color, but not too much, because we do not want to erase them completely.

We apply new shadows over the previously blended areas. This repetitive process is not unusual when working with charcoal. The different tones are established with the progressive darkening of each area.

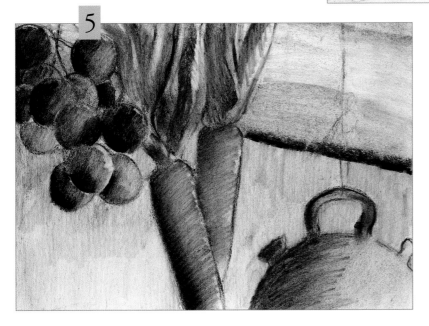

5

To finish the shading effect on the objects, we blend the shadows with a blending stick; this is why the shaded areas show the characteristic line marks. The main objective is to cause each form to show a tonal gradation that gives it depth.

6

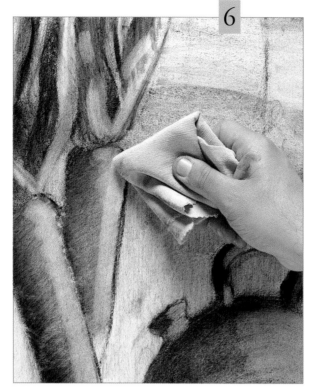

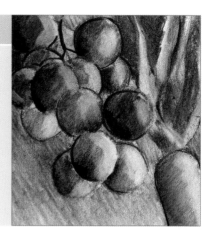

When all the objects are completely shaded with charcoal, we lighten the illuminated area in each one of them, gently rubbing with a clean cotton rag. By doing this we emphasize the contrast between light and shadow.

7

We apply the final touches with a blending stick. A line is drawn across the background to create greater contrast for the objects, which stand out against it.

To finish, we touch up some of the outlines with the tip of the stick. At this point, the drawing is shown shaded, darkened, but not completely finished; from here on, we can finish it by emphasizing the details or highlighting the contrasts with charcoal or chalk.

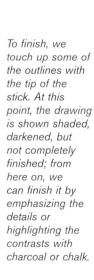

The STICK: ACTION *and* MOVEMENT

We must learn how to use the stick (whether charcoal, sanguine crayon, or chalk) properly, to be able to get the most out of it. To do this, it is necessary to combine the line with the side, edge, or the flat of the stick; in other words, to draw with any of its sides. Therefore, it is important to study how to apply variations of lines and shading, and what effects are derived from sudden changes of direction or from rotating the stick during the drawing process.

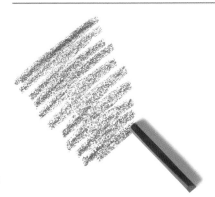

If, instead of working with the edge, we work with the flat side of the tip or with the side, the line will be wider and will provide a characteristic texture.

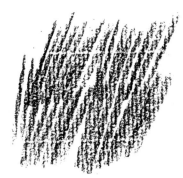

By drawing with one of the edges of the stick of chalk or charcoal we create very fine lines similar to those drawn with a pencil.

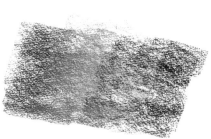

Shading with the bar flat makes it possible to draw quickly. Its extension depends on the width of the stick. This always creates a textured effect, which can be mixed by juxtaposing it or superimposing it with other colors.

If we work with the charcoal stick in the horizontal position, with each layer of color or with the gradual increase of pressure, we will produce different intensities of gray.

As we move the stick to the perpendicular position, the width of the stroke narrows. We should use this motion to control the width of the shading.

It is a good idea to practice with different strokes, changing the position of the hand. Shown here is a diffused area of shading done with rotating motions.

If we use a stick to draw, it can be rotated slightly to control the direction of the stroke.

35

DRAWING
with charcoal

DRAWING *with charcoal and* COMPRESSED CHARCOAL

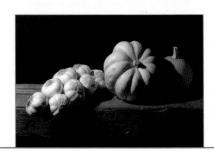

With this drawing we are going to learn, step by step, the process for shading with the chiaroscuro technique using a stick of charcoal and a stick of compressed charcoal. The intense light of the model provides strong contrasts between the illuminated areas and the shaded areas, which emphasizes the effect.

1

First, we make a basic drawing of the general shapes of the objects that are part of the still life. We work each element with rounded shapes that will serve as a base for the subsequent tonal construction.

To draw the pumpkin, we first divide it with very thin radial lines. The sections are asymmetrical and have different widths.

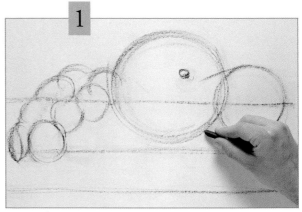

2

Advice

Before drawing the geometric shapes, it is very helpful to draw a line for the table on which we will place the various curves and circles to create a composition that is centered and balanced.

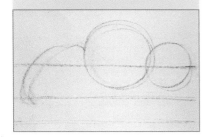

Using the sharp tip of the charcoal stick, we go over the lines previously drawn so the vegetables begin to acquire a more convincing shape. The pumpkin must clearly show its three-dimensionality and structure.

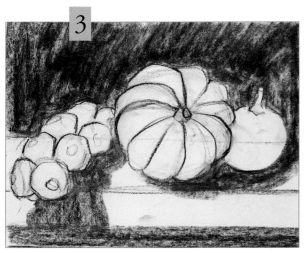

3

The largest shaded areas are created with the flat side of a stick of charcoal. We press hard to create dark black tones. We must keep in mind that the black from the charcoal is going to be lightened when we begin to blend.

The medium tones for the vegetables have been created with more shading and subsequent erasing, which has covered the white color of the paper. At this point, we go over all the lines and contours of the still life with the tip of a stick of compressed charcoal.

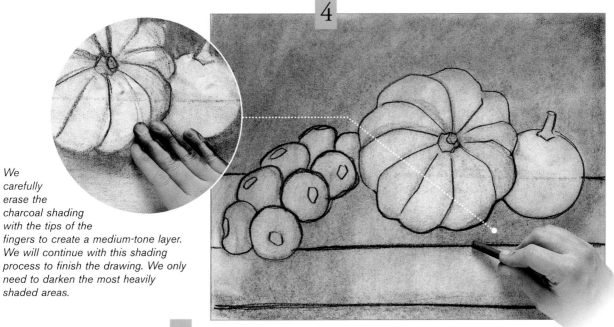

4

We carefully erase the charcoal shading with the tips of the fingers to create a medium-tone layer. We will continue with this shading process to finish the drawing. We only need to darken the most heavily shaded areas.

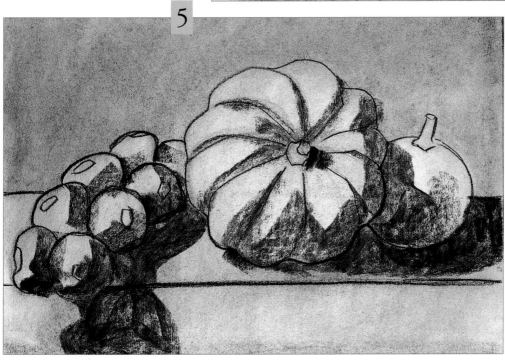

5

We emphasize the volume of the still life by adding a new layer of shading over the previous ones, drawing with a longitudinal piece of charcoal. The outlines of the shadows are perfectly defined.

6

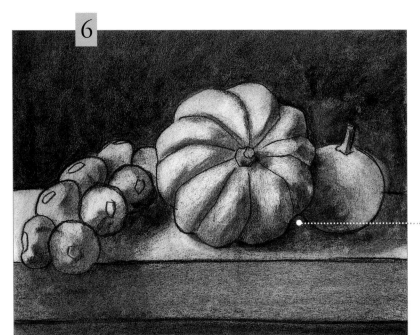

We continue working with the side of the stick of charcoal, this time darkening the front area of the table with a medium gray and covering the background with a dark black by applying more pressure with the stick.

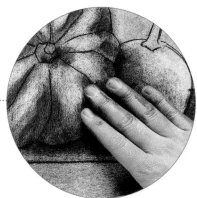

The shadows of the vegetables are blended with the fingertips, barely touching the paper, as if caressing it, to avoid removing too much of the charcoal.

We emphasize the contrasts by drawing with the stick of compressed charcoal to create darker blacks.

7

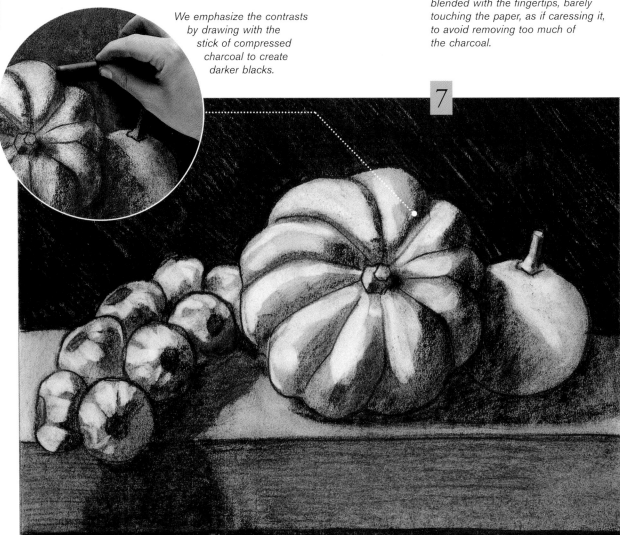

Again we intensify the shadows projected by the vegetables on the wood beam with the side of the stick of compressed charcoal. When we rub the shadows with the fingers the blacks become more compact. Finally, we lighten the illuminated areas with an eraser.

NOTES *on* CHIAROSCURO

To highlight the chiaroscuro effect from the previous exercise, we emphasize four absolutely necessary steps aimed at intensifying the shadows, preserving the profiles of the objects, and creating maximum contrast between the most-illuminated areas and the most-shaded ones. Dismissing any of them would ruin our pursuit of drawing an object using chiaroscuro.

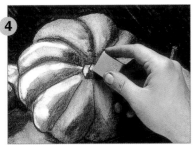

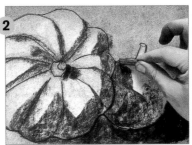

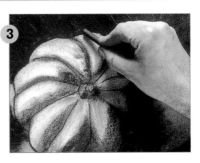

1. During the initial phase of the drawing, we shade the largest areas with the side of the stick of charcoal. We work very loosely, applying a great deal of pressure and without stopping at details or at the shadows inside of the objects.

2. Over the previous shaded surface, already blended, new shades are applied. Chiaroscuro requires the shaded areas to be very dark. We must be decisive and work with the side of the stick of charcoal.

3. When charcoal reaches its level of maximum saturation, we begin to shade with compressed charcoal, which produces very intense blacks. This way, the outlines of the objects will stand out in contrast against the black background.

4. We expose the initial white of the most-illuminated areas of the still life with a kneaded eraser. The great tonal difference that exists between the white of the lighted areas and the absolute black of the shadows emphasizes the sense of volume.

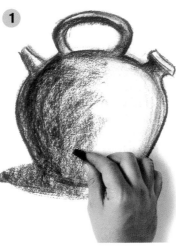

1. Let us review with another example of how to develop the concept of chiaroscuro with a stick of charcoal. Once the object has been sketched out, we shade a wide area with the stick while applying pressure.

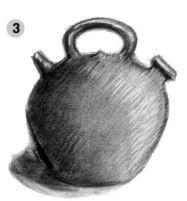

2. We model the previous shading with the hand. The result should be a gradated area. We shade and blend over the previous layer as many times as needed until a very dark tone has been created.

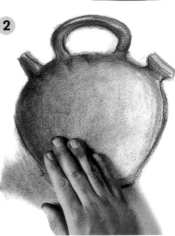

3. The shaded area is sufficiently dark to produce the chiaroscuro effect. To achieve such effect, we create some highlights for the most-illuminated parts with an eraser, using its tip to create some crosshatching.

39

MODELING
with SANGUINE CRAYON

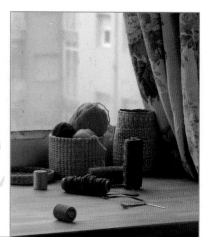

Sanguine crayon is a very warm and quiet medium that has been chosen for the following modeling exercise, in which we create a still life with very diffused shading and without abrupt tonal changes. To avoid any distractions during the modeling process, we draw the still life as if it consisted of simple volumes, without paying attention to the specific details or textures of each object.

During the first phase of the sketching process, we use a very soft sanguine pencil so it can be easily erased. Very little pressure is needed to draw the lines.

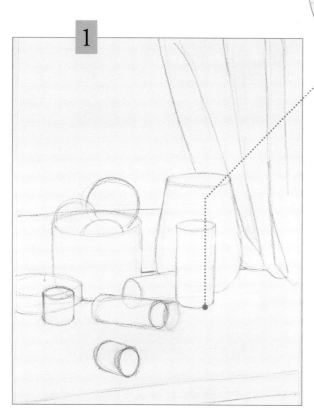

The first drawing is very light. It is a good idea to draw the contours with a trial-and-error approach, therefore we should draw lines that are easy to erase.

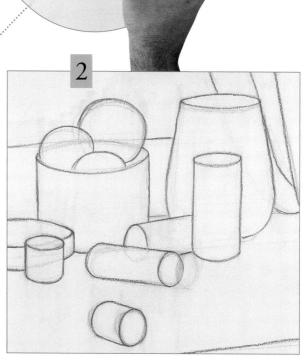

Once we have decided on the placement, we go over the objects with a heavier line using the tip of a sanguine crayon. All the objects have been reduced to simple geometric shapes.

3

The first shading effects done with any of the rubbing techniques, whether using charcoal, chalk, or sanguine, are applied with the stick held horizontally; this is a step that cannot be avoided.

The first shadows are applied with the sanguine crayon in the flat position. The idea is to differentiate the shaded area from the lighted one. In the areas where the shadows are more intense, we press the stick harder against the paper.

5

Creating tonal values is an ongoing process; we add a second layer of shading over the previous one with the stick held horizontally. This time we ignore the light areas and the intermediate shadows and work only on the darkest shadows.

4

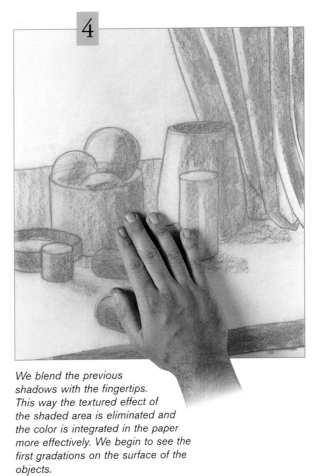

We blend the previous shadows with the fingertips. This way the textured effect of the shaded area is eliminated and the color is integrated in the paper more effectively. We begin to see the first gradations on the surface of the objects.

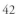

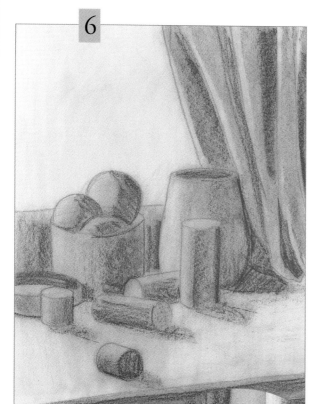

6

We blend the second layer of shading with the hand. We can see how the objects, which already show gradations with light tonal transitions, begin to acquire shape.

7

To begin erasing, we use a kneaded eraser, which easily removes the pigment of the crayon. Erasing defines the shapes.

We reinstate the highlights by erasing with an eraser. The goal is to expose the color of the paper to show where the light that enters through the window falls. By creating highlights we emphasize the volume of the objects.

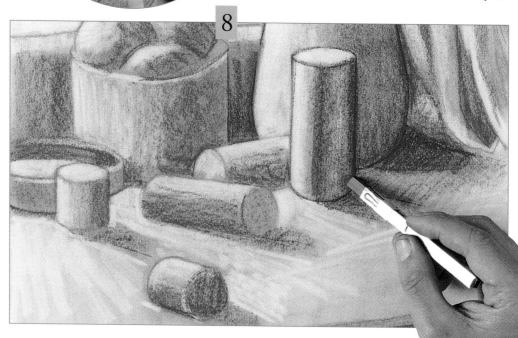

8

We switch from shading with the crayon in the horizontal position and continue modeling with the tip of the stick, inserted into a metal holder, which makes it easier to handle.

The idea in this last phase is to work mainly on the darkest areas and to model them delicately, using a small blending stick. If we used the fingers we would muddy the area.

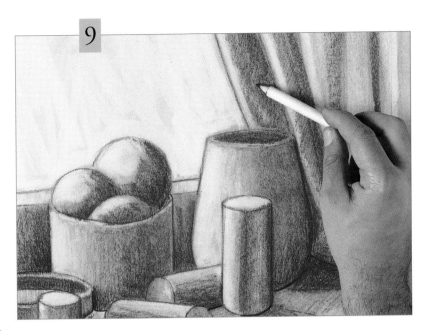

The shadows of the objects and some of their profiles, which have been erased during the blending process, are intensified and redefined with the tip of a stick of brown chalk. We darken and model the shadows of the folds of the curtains with a medium-size blending stick.

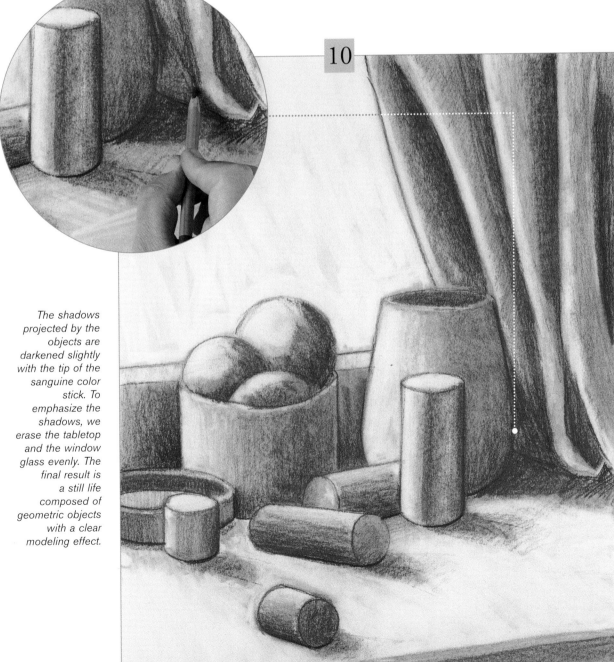

The shadows projected by the objects are darkened slightly with the tip of the sanguine color stick. To emphasize the shadows, we erase the tabletop and the window glass evenly. The final result is a still life composed of geometric objects with a clear modeling effect.

Work by STUDENTS

Now we will see how the previous sanguine drawing by a professional artist is replicated by art students as part of their learning process. The art students have drawn different models with sanguine crayon, and each of them has applied a different approach. Their execution and interpretation of the shadows and the modeling, and the differing results, are worth analyzing and comment. Learning from their accomplishments and successes can inspire the readers and help them to make progress with their own work.

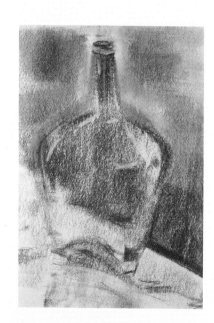

We can observe how lines are almost nonexistent in this drawing. The volume of the glass carafe has been constructed with the side of the sanguine stick. The shape of the object, its transparency, as well as lighting effects have been created by applying more or less shadow in each area. The shape is emphasized by blending and gently erasing the background and the texture with an eraser. Drawn by Margarita Puig.

Objects as simple as glass bottles offer an interesting testing ground for any student to practice how to define both outline and shading. The darkest areas (outline, neck, and base of the bottle) are drawn with more intense strokes, whereas the areas of greater transparency are created by blending the sanguine with the fingertips. Executed by Marta Campillo.

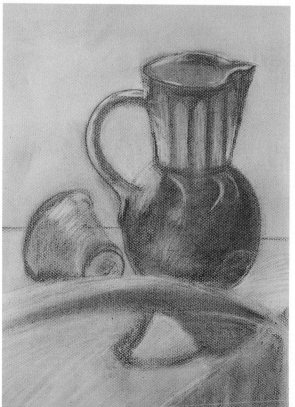

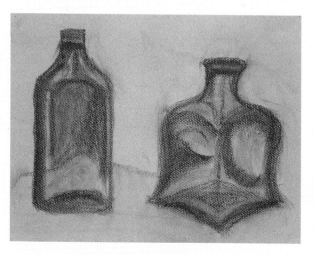

This still life of geometric shapes has been drawn on a toned paper, that is, a paper that has been previously shaded with sanguine powder. The shading of the pitcher is dark, its tone has been nearly evenly applied. Areas of light are created on this surface with a kneaded eraser. The cup has lighter tones. The erasing process conveys its shiny and glossy surface. Drawn by Inés Rabanal.

This work was begun with charcoal, blending each new application. Then the outlines of the objects were darkened with sanguine crayon and light color was applied to the table. To conclude, strokes of brown chalk were applied more boldly, which combined with the charcoal, providing the final tone of the shaded areas of the model. The objects acquire luminosity and gloss as a result of the selective erasing done with a kneaded eraser. Drawn by Pere Belzunce.

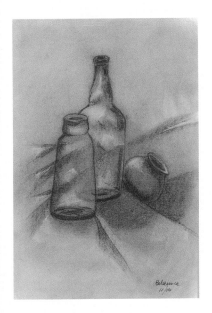

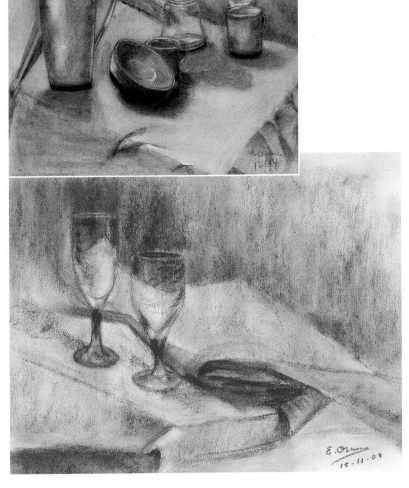

Here, the outlines of the objects have been drawn with firm and decisive lines, stressing the exactness and correctness of the outlines of the objects. Delicate shading has been applied to them with the side of the stick, gently erasing the lightest areas at the same time. This gives the objects a certain modeled effect, constructed with subtle gradations. Executed by Pere Belzunce.

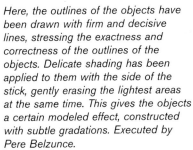

The modeling of this drawing has been worked with light lines, darkened where needed with new overlaid lines gradually reinforcing and defining every detail. As a result, the modeling of the glasses has been done very lightly. Once the shapes are drawn, we move on to the darker areas. The lighter cloth has been shaded by rubbing. Drawn by Encarnación Osuna.

Rural SCENE
with the FLAT SIDE

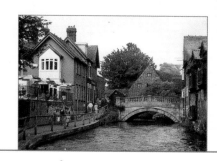

The general idea for shading is very simple: the goal is to move progressively from light tones to dark tones, and vice versa. But this basic idea can be approached from different angles, depending on the technique used. In this exercise, we are going to shade a rural scene with chalk, using only the long side of the stick. This method has an inconvenience, which is that we will not be able to produce a wide range of tones. The great advantage is that we can treat each area at its fullest, in a general way, without getting lost in the details.

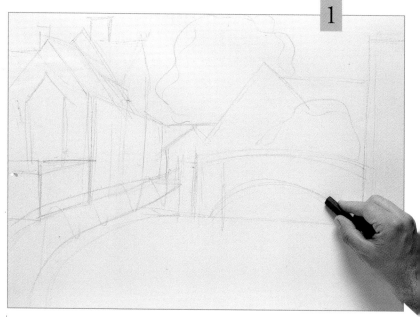

The sketch is created with lines using a stick of chalk, without any shadows and disregarding perspective. We simply pay attention to the approximate shape of each façade.

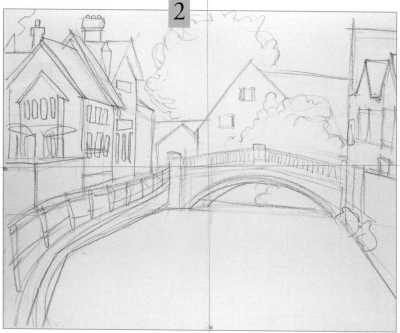

The previous drawing is completed by pressing harder on the tip of the chalk to define the outlines. It is not important to be exact with the drawing; rather, the goal is to be accurate with the proportions.

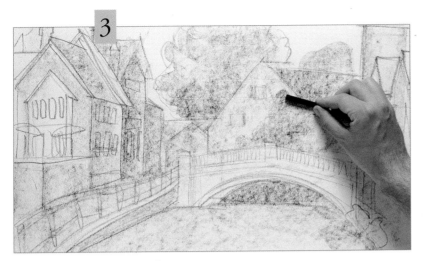

3

We shade with the full length of the stick of chalk held horizontally. This is the first, very general, layer of shading, created to apply the light tones, which will allow us to establish the gradual transition between light and shadow.

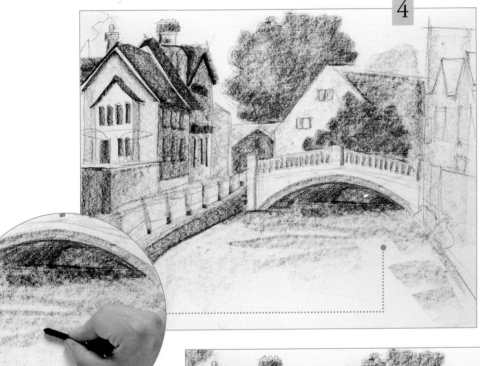

4

We break the stick in half, and we continue shading the vegetation, the roofs, and the façades of the houses, highlighting the main tonal differences that exist between the medium and the light tones of the previous step.

The surface of the water is created with a zigzag motion, with the stick always held flat. For the time being, the lines are light; we will darken them later.

5

We break the stick again to end up with a three-quarter inch piece (2 cm). We draw the darkest shadows for the vegetation and the area under the bridge. This is achieved by applying more pressure on the stick.

We apply darker, contrasting shadows to the vegetation, darkening also the edges of the water and the façades of the houses. Because we are using the stick in the horizontal position, we can only apply shadows, as seen on the bridge's railing, which have no details.

Advice

If needed, we can complement the monochromatic approach of the drawing by adding new shading with ocher chalk. This way we will combine two colors to create a more attractive finish.

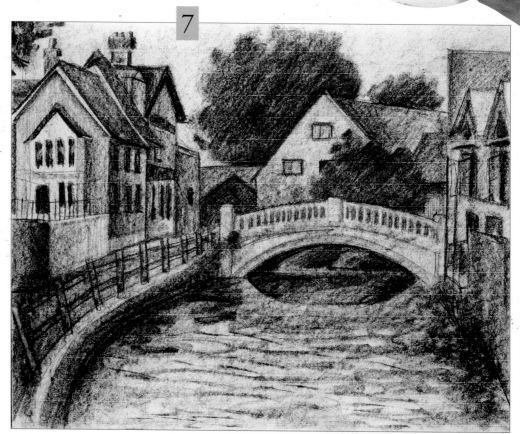

We finish the water with new zigzag shading, leaving some areas uncovered to expose the white of the paper to simulate the reflections of light.

We conclude the drawing by working on each area, touching up the tones and adding some lines to help define chosen outlines. The final result is a very well-blended work of shading, a simple drawing using only a few variations to show nuance and detail.

WORKING *with the* STICK FLAT

Shading with the stick in the flat position produces a stylized drawing. To be able to draw correctly, it is important to remember that the changes in pressure determine the tone of the shading and that the size of the stick provides greater or lesser detail in the treatment. Because this method does not provide the ability to draw clean lines, we must use a circular motion to better express the outlines and the textures of the elements represented. Here are some examples of the applications.

When working with the flat stick, it is important to choose a medium that is appropriate for the paper. We can test the medium to make sure that the shading effect is the one we are looking for.

It is important to adjust each shading application to the size of the bar. If we intend to make a wide stroke with a short stick, we will need several staggered strokes to cover the surface.

The only lines that we can create with this method are the ones applied in a zigzag motion, moving the bar the long way.

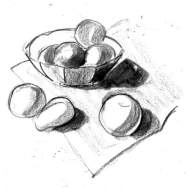

In any drawing, flat shades are applied first. Later we can always decide whether to blend or to continue using this technique.

To draw this study of a figure, we first create a line drawing. Then we apply a well-blended and homogenous shading with the side of a piece of stick.

This way the part of the body that is in the shadow can be covered very quickly. The stroke applied with the stick held flat must be continuous and as long as possible.

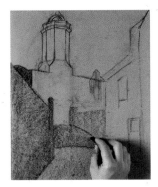

Whether using charcoal or chalk, after blocking-in the drawing, we must apply flat shading. First, the areas of light and shadow should be distinctly separated.

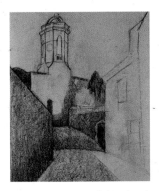

Then, each area of the drawing must have different shading intensities to make sure that each plane is properly represented.

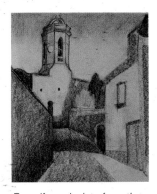

Even if we deviate from the model, the shading in certain areas should be darkened to increase the contrast with the adjacent ones. Gradation is a good approach in such cases.

49

Drawing with
CHALK

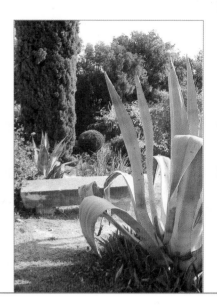

Drawing with BLACK *and* WHITE CHALK

This technique, also known as the "two-color tech-nique," produces a drawing with great contrast between the illuminated areas, highlighted with white chalk, and the shaded ones, done with the deep black charcoal. The effect created is photographic and has great depth. To get the most out of the black and white contrast, we will use a gray paper. The medium tones provided by the gray background make it possi-ble to soften the transition between the two colors.

The first layer of the drawing is applied with the entire length of the charcoal stick held flat on the paper. The strokes serve to draw the vegetation and at the same time to establish the medium tone of the shadows. A little more pressure is applied for the cypress tree to make its shadow visible.

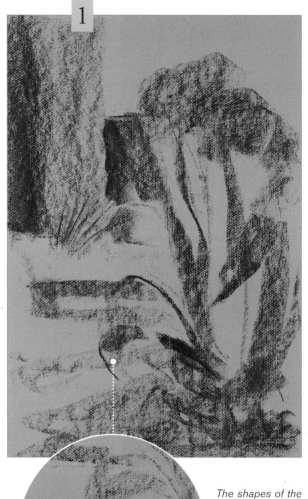

The shapes of the vegetation are established with a quick drawing. We sketch out the shadows, holding the charcoal stick flat between the fingers and without applying too much pressure.

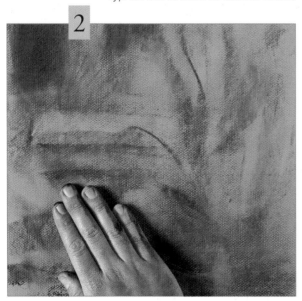

The vegetation in the background is darkened with covering strokes. Once the deepest shadows have been drawn, we blend the tones by rubbing with the fingertips.

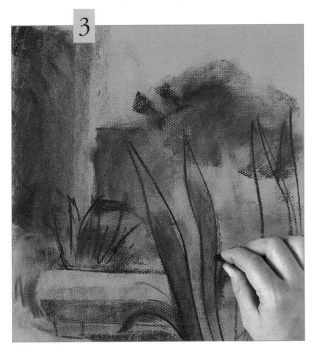

3

While darkening the shadows, we incorporate the lines that define the vegetation in the foreground. At this point it is a good idea to alternate between the side of the charcoal stick and the tip.

The color of the paper is left exposed for the most luminous tones, while we increase the darkness of the shadows to differentiate the main tonal areas. The middle tones of the ground and the stone bench are made with light charcoal shading.

Advice

Shading with the side of the charcoal stick makes wide and crude lines. There is little possibility for creating details, so the drawing is made by using shading rather than lines.

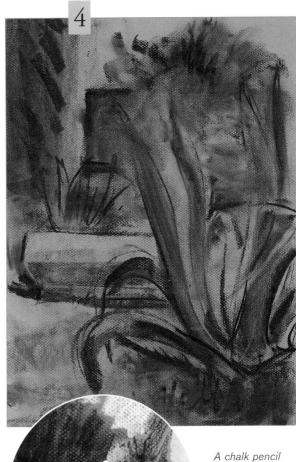

4

A chalk pencil held sideways is used to apply intense and covering strokes; this way, the division between the sky and the trees is clearly delineated.

The sky is colored with white chalk to emphasize the outline of the vegetation. The texture of the cypress tree is obtained by lightly caressing the surface with the stick placed sideways. The contour of the plant is outlined with the tip of the chalk.

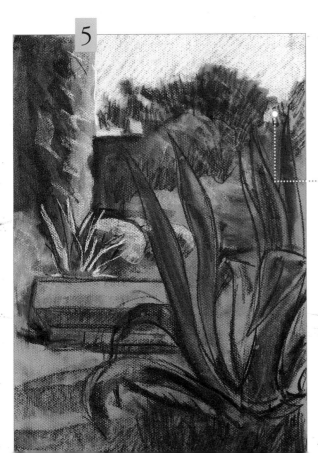

5

51

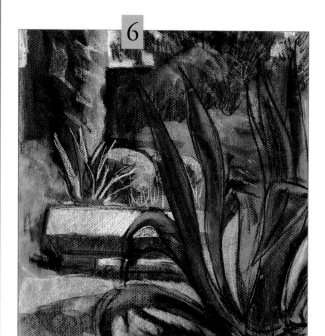

Using the flat side of the white chalk, we color the area that represents the ground. To lighten the empty spaces between the leaves of the plant located in the foreground, we work with the tip of the stick, barely applying any pressure.

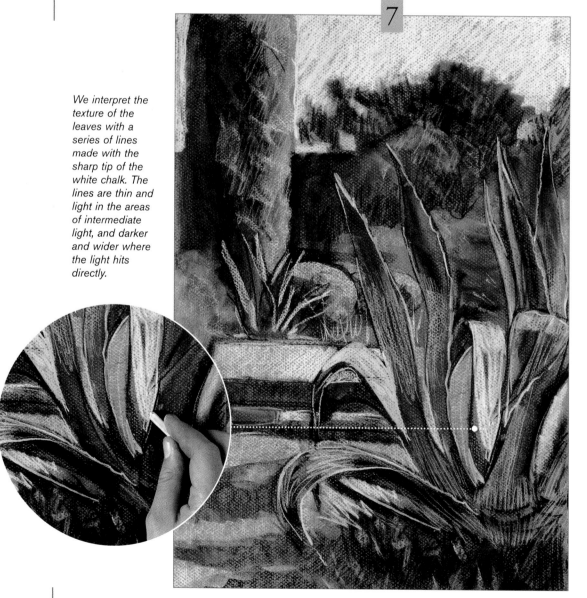

We interpret the texture of the leaves with a series of lines made with the sharp tip of the white chalk. The lines are thin and light in the areas of intermediate light, and darker and wider where the light hits directly.

We complete the nearer plant with new whites applied with the tip of the chalk. We stroke it with thin, precise lines that help better indicate the texture. It is a good idea to vary the darkness of the lines. This establishes different planes for the positions of the leaves with respect to the light.

WHITE *over* BLACK

Combining two disparate colors such as black and white on the same ground can be a disconcerting experience for the beginner. The process requires order: first the drawing is shaded with black, and then the whites are incorporated. However, this is not enough. It is also important to know how we can combine, mix, blend, and layer these two colors as a way to create specific effects and textures. Below are some examples.

The gradations between the two colors help to emphasize the effect of volume and allow us to transition between absolute darkness and blinding light very quickly.

The sky can be represented by creating a uniform layer of white or by forming light and diffused gradations between the two colors.

It is important to study the tonal possibilities of white chalk on gray paper. Creating a simple tonal test will help us verify the tones that we will be able to achieve.

White and gray, in addition to being applied in their pure form, can be mixed. We can produce different values of gray by varying the mixture of both colors.

We can make full use of the paper's color by applying light layers of charcoal.

When drawing vegetation with these two colors, it is important to differentiate the lighted areas from the shaded areas. We must rub the white chalk lightly over the area shaded with charcoal, as if caressing it.

By gently working the charcoal-covered surface with white chalk, we will create gradations of light, diffused and imprecise textures that are very appropriate for representing the vegetation in the distance.

We reserve crosshatching with white chalk for the foreground. Higher definition of the lines on the closer objects emphasizes the effect of depth.

The light and defining lines of the white chalk are much more visible if they are drawn over an area that has been previously shaded with charcoal, rather than applying them directly on the medium gray of the paper.

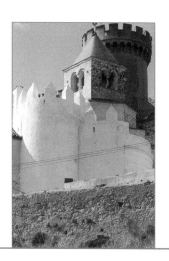

DRAWING with
CHALK in THREE COLORS

DRAWING
with CHALK

To create a gradual transition from light to shadow, or from one color to another, we can use a variety of techniques for mixing colors. The rich tones of a drawing done with charcoal can be blended with color chalks to highlight the volume of the model and to achieve a colorful effect. We will look at an example of an exercise drawn with charcoal and black, white, and sanguine chalks on ocher paper.

Advice

A preliminary geometric diagram is an excellent guide for incorporating the architectural details gradually and for properly laying out the characteristic features of the building.

Before blocking-in the drawing, it is important to study the model and to look at it as if it were a series of superimposed geometric shapes. This first analysis should be very quick, made with lines drawn with a stick of vine charcoal.

1

We modify or strengthen the architectural lines by drawing straight lines with the side of the stick over the basic sketch.

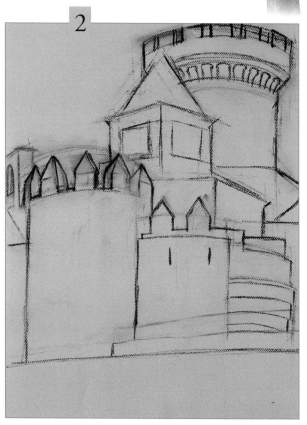

2

Once the geometric diagram is completed, we begin to draw with the charcoal stick. Using the precision allowed by the tip, we try to draw the details of the battlements of the wall and the tower. Then we will focus on the details.

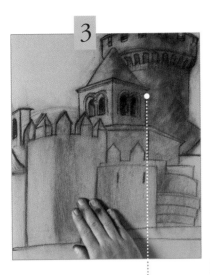

3

Once we enter the shading phase, we apply the shading with the stick of charcoal placed sideways and then immediately blend the areas with the palm of the hand.

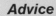

We touch up the outlines of the architectural features with black chalk to prevent them from being erased each time we do the blending.

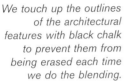

Advice

To finish this phase, we blend the sanguine and black chalk shadows with the blending stick. This makes the colors more compact and even.

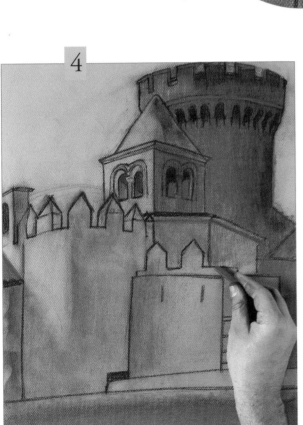

4

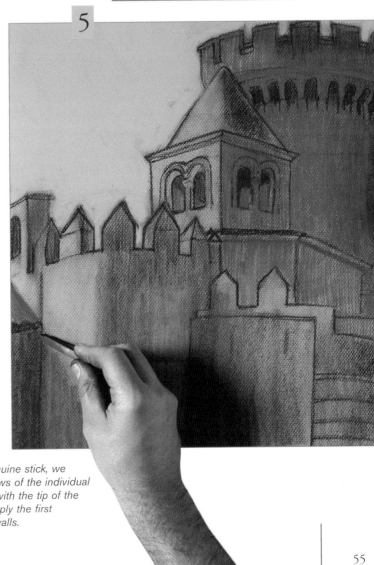

5

Sanguine crayon is a good tool for resolving the middle-tone areas. We begin by coloring the circular tower in the background. In this area, we blend the sanguine color with the previously applied charcoal, creating a large area of shadow. With the same color, we apply light shading to the rear of the church.

Extending the sanguine stick, we contrast the shadows of the individual forms by working with the tip of the black chalk. We apply the first gradations of the walls.

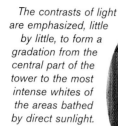

When we apply the first white highlights, the building begins to look very realistic. The whites of the walls are slightly gradated to increase or decrease their intensity, depending on whether the area has more or less light. We differentiate the bell tower's lighted wall from the shaded one.

The contrasts of light are emphasized, little by little, to form a gradation from the central part of the tower to the most intense whites of the areas bathed by direct sunlight.

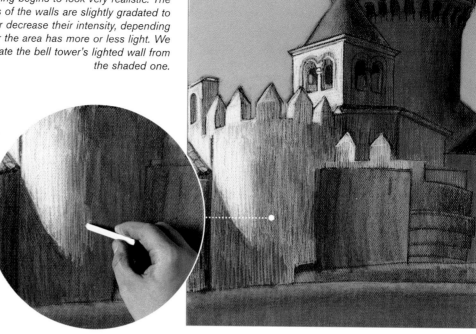

6

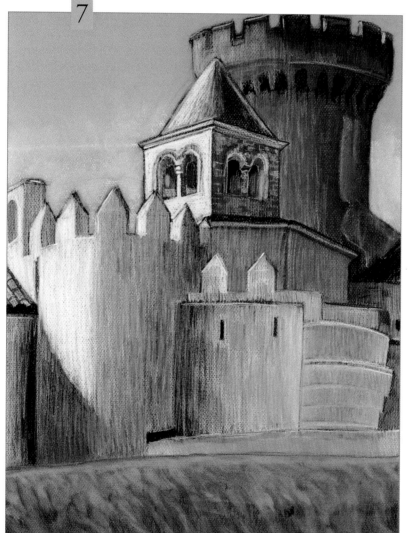

7

Advice

To differentiate the wall in the foreground from the more distant architectural features, we erase several areas with a kneaded eraser to create a textured effect.

With the stick tilted sideways, we gently whiten areas of the circular tower and the top of the bell tower. The finished drawing offers a strong three-dimensional effect. Using white chalk to represent the areas of light, we have emphasized the circular form of the wall's outstanding features and the contrasting sides of the bell tower.

GEOMETRIC VOLUMES

When confronting this type of project, we must learn to visualize the forms as geometric shapes, understanding them as if they were three-dimensional geometric bodies. Therefore, the architecture is approached as a puzzle made of different superimposed shapes. The incidence of light over these bodies should also follow the same selective criteria. We must observe how light reacts on each volume. We will analyze the final image of the previous example.

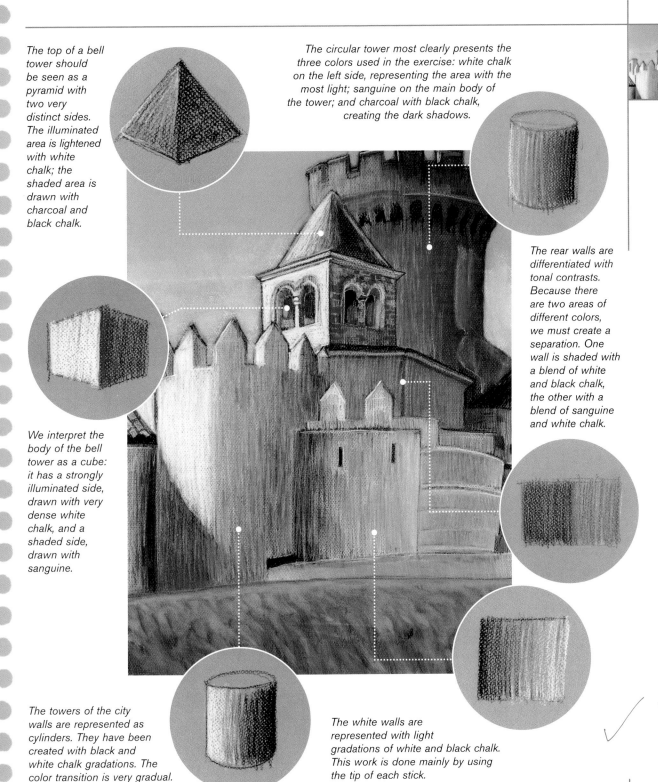

The top of a bell tower should be seen as a pyramid with two very distinct sides. The illuminated area is lightened with white chalk; the shaded area is drawn with charcoal and black chalk.

The circular tower most clearly presents the three colors used in the exercise: white chalk on the left side, representing the area with the most light; sanguine on the main body of the tower; and charcoal with black chalk, creating the dark shadows.

The rear walls are differentiated with tonal contrasts. Because there are two areas of different colors, we must create a separation. One wall is shaded with a blend of white and black chalk, the other with a blend of sanguine and white chalk.

We interpret the body of the bell tower as a cube: it has a strongly illuminated side, drawn with very dense white chalk, and a shaded side, drawn with sanguine.

The towers of the city walls are represented as cylinders. They have been created with black and white chalk gradations. The color transition is very gradual.

The white walls are represented with light gradations of white and black chalk. This work is done mainly by using the tip of each stick.

LANDSCAPE *with* BLENDING *Techniques*

In this exercise we are going to combine the charcoal stick with chalk. We begin by shading with charcoal, which we alternate with blending. When the entire surface of the paper is covered, the initial charcoal drawing begins to lose its presence. The remaining light and medium tones form the base for the subsequent work with black chalk, which will be used to develop the darker gray of the trees and the foreground.

1

We begin the drawing by identifying each plane of the landscape with tentative lines. The thin, light lines are drawn with the side of a broken piece of charcoal.

Advice

Sfumato is a good method for drawing vegetation and landscapes. The line's imprecision, along with blending helps define the irregularity of the foliage.

We layer darker grays over the previous drawing with the side of a charcoal stick. The lower part of the drawing is done the same way, although with less pressure than is used for the outline of the mountains.

2

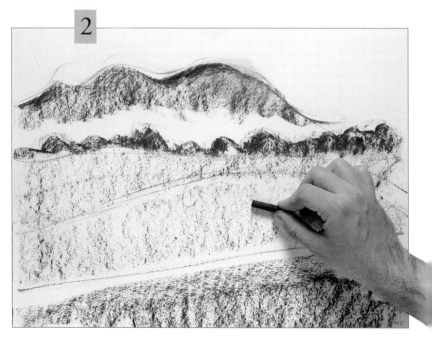

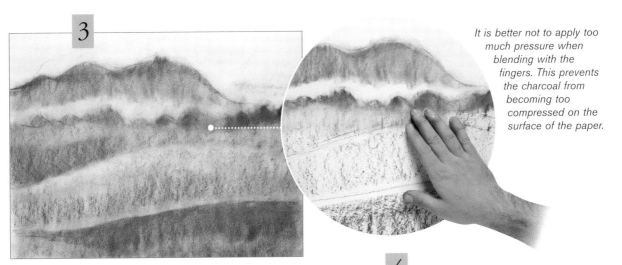

It is better not to apply too much pressure when blending with the fingers. This prevents the charcoal from becoming too compressed on the surface of the paper.

We blend the charcoal shading with the hand to lighten the tones and to better integrate the pigment into the texture of the paper. We leave an area uncovered to depict the fog that forms at the base of the mountains.

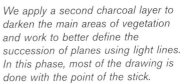

The background is drawn with light shadows and with barely any details. We must keep in mind that the gray made with chalk will look darker when blended with the blending stick.

We apply a second charcoal layer to darken the main areas of vegetation and work to better define the succession of planes using light lines. In this phase, most of the drawing is done with the point of the stick.

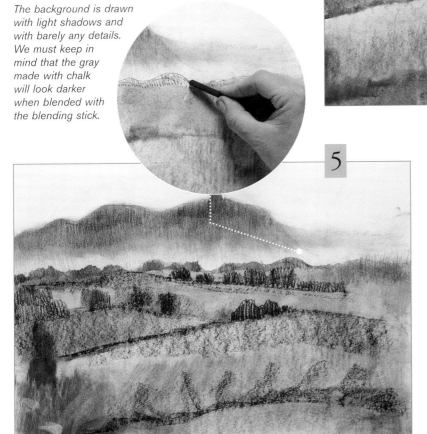

Advice

Before a new layer is blended over the mountains in the background, light lines can be drawn with the tip of the chalk so the final shading shows clear gradations.

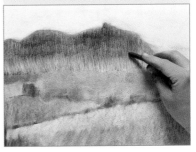

With the tip of a black chalk we begin to draw the first trees over this medium gray base. The tones of the trees in the background are light; the blacks become darker as the ground moves towards us.

We blend the shading applied with black chalk with a blending stick, keeping in mind that this material darkens considerably and adheres to the paper better than charcoal. The groups of vegetation look like dark spots that contrast with the surrounding terrain.

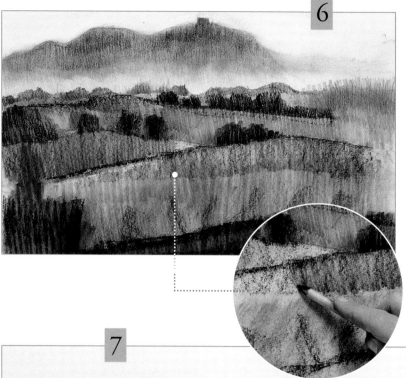

6

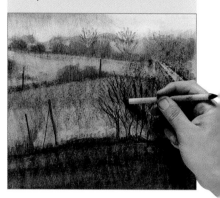

When using the blending stick, we must keep in mind the direction in which we move it. For the vegetation, it is a good idea to follow the direction of the growth of the trees, bushes, and other plants.

7

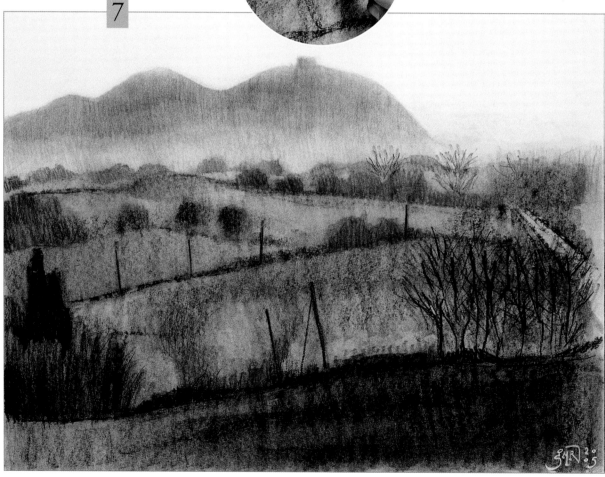

Before we finish, the entire drawing is rubbed with the hand to remove any visible lines. The vegetation in the foreground and the posts are defined with the tip of the chalk. The final result should incorporate a gradation that progresses from the darkest tones of the foreground to the lightest ones in the background of the landscape.

PRACTICE *with* BLENDING

When we make an atmospheric drawing with a heavy use of sfumato, it is a good idea to vary the blending effects. This allows us to create results that are appropriate for each area of the landscape. Below we review several effects that are important to keep in mind when doing this type of work.

The foundation for any blending application is a gradation. When drawing a landscape, describing the fading quality of the distant planes is vital. This effect is seen in the mountains in the background.

The groups of vegetation are represented with lines drawn with the side of the charcoal stick.

The diagonal lines of the terrain are drawn with the flat side of the charcoal stick. They produce a broken effect that goes well with blending.

We will compare three different ways of blending a short tonal range. In this first example, the tonal scale is done with the stick held sideways, without blending.

Blending with the fingers tends to spread the charcoal too much and that unifies the tones. This is a very good approach for creating flat surfaces.

The precision provided by the blending stick makes it possible to blend the pigment of each area separately, preventing colors from mixing. The blending stick makes the shadows denser and darker.

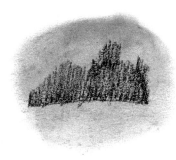

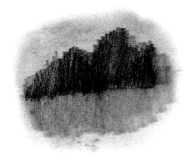

Black chalk makes coarser lines that are not as covering as charcoal. Here is what the mid-ground vegetation would look like.

Rubbing the previous drawing with the angled tip of the blending stick intensifies the chalk lines and integrates that area with the ground plane.

To represent the group of leafless trees in the foreground, we draw the branches with the tip of the chalk stick. We then create small lines by rubbing with the tip of the blending stick.

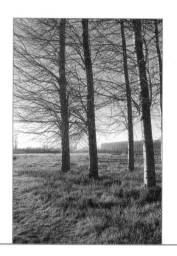

DRAWING *with the* ERASING TECHNIQUE

As we will see in this step-by-step exercise, the results of erasing can become a perfect complement to help emphasize the light in a drawing. In this approach, we learn to consider the dark areas of a drawing as part of the process, making it easier to define the areas of light. This drawing technique is especially good when the subject matter has strong chiaroscuro and contrasting light. The materials that we are going to use in this exercise are a stick of charcoal, a clean cotton rag, a kneaded eraser, and our own hands for blending.

Advice

The initial shading must be done with the stick of charcoal held completely flat.

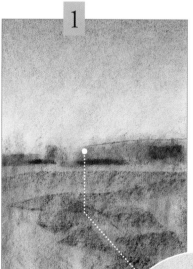

1

We prepare a toned background, darkening the white paper so the effects of erasing will be visible. The landscape is drawn with very generalized shades, taking a somewhat abstract approach and paying no attention to the trees in the foreground.

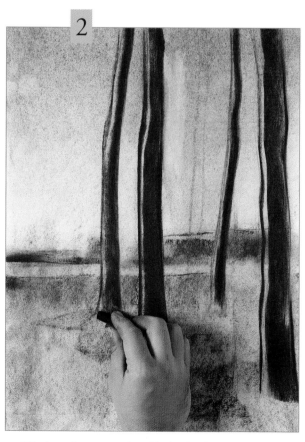

2

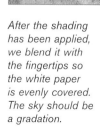

After the shading has been applied, we blend it with the fingertips so the white paper is evenly covered. The sky should be a gradation.

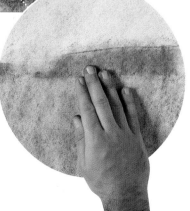

We draw the tree trunks with the tip of the stick to make a strong line. The shading is done with the charcoal held flat, applying pressure to make the black very dark. We leave a small open line, which indicates an area of light on the tree.

3

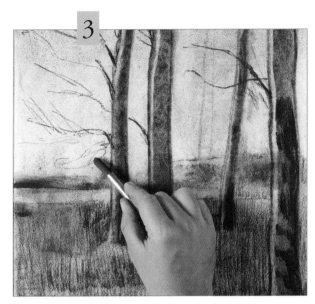

We shade the grass-covered ground with small vertical lines. The direction of the stroke helps define its texture. Then we patiently draw the many tree branches using thin rounded lines again, although this time somewhat stronger.

The small spaces in between the branches are erased with a molded kneaded eraser to make the sky more luminous and to highlight the silhouette effect.

4

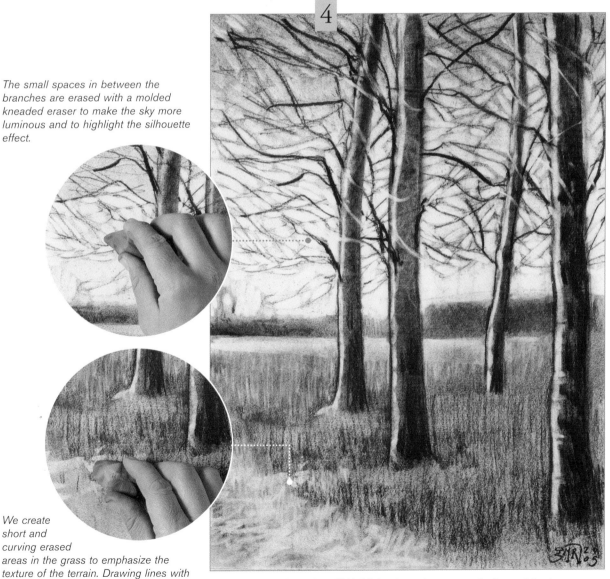

We create short and curving erased areas in the grass to emphasize the texture of the terrain. Drawing lines with the eraser can also be complemented by touching up with the fingers to tone down any excessive white of the paper.

Erasing parts of the sky will highlight, through contrast, the lines of the tree branches, whereas erasing the ground helps define the terrain. Creating a horizontal line below the horizon line with the eraser opens new highlights.

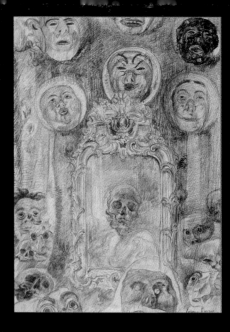

James Ensor, The Mirror with Skeletons, *1890. Black chalk. Private collection.*

JAMES ENSOR (1860–1949)

James Ensor, Self-portrait with Hat with Flowers, *1883–1888. Oil. Museum voor Schone Kunsten (Ostende, Belgium).*

Belgium painter, printmaker, and writer, he was one of the boldest artists of the latter part of the nineteenth century. Cultivating both Symbolism and Expressionism, his contributions were important at the time and greatly influenced the Expressionist artists. He lived in a world inhabited by demons, monstrous creatures, and metamorphosed beings.

His was a world of fantasy that revolved around allegory and visual metaphor. In these imaginary surroundings, masks became his deepest disguise, and they explain his personal drama. They are a menace and protection at the same time: "Masks, animals of the Ostende Carnival, vicuña disguises, birds with broken wings, blue-beaked cranes speaking nonsense . . . it is all like a giant carnival that symbolizes the modern streets."

Toward the end of the nineteenth century he created his most interesting drawing series with chalk and conté crayons, inspired by this macabre atmosphere full of ghosts, masks, and angry skeletons, which he combined with an intentionally wild technique, justifying the quote: "The proper line cannot inspire grand feelings. It does not call for any sacrifices, for any profound combination. An enemy of genius, it cannot express the passion, the ambition, the fight, the pain, the enthusiasm, such beautiful and grand feelings, or any other decision made. Its triumph is foolish: it has the approval of superficial and limited spirits, it represents that which is feminine. . . ."

As a result of his vertiginous line, the eye of the spectator can hardly find a place to rest in his drawings, with its figures or inscriptions that constantly require our attention. The result appears agitated and intense, devoid at first sight of any unifying principle. The figures look monstrously degenerated, composed by out-of-control lines, indecisive profiles that aim at moving and irritating the spectator: "The crazy lines create an impact, they immediately cause an impression. They lead us to vertigo, to chaos, but they heighten the drawing with incredible flights."

The nervous forms are pierced by a light whose lines shine like fireflies. He achieved this effect with a very personal method and by spreading white among the other lines. The author himself says that: "The first vision, the most vulgar one, is the simple, dry line, without any color. The second analysis is where the trained eye distinguishes the tonal values and the nuances. The last step is the one where the artist sees the subtleties and the many light combinations, their planes, and gravitations. Progressive explorations modify the primitive vision, and the initial line suffers and becomes secondary, promoting disarray, chaos, and that which cannot be corrected."

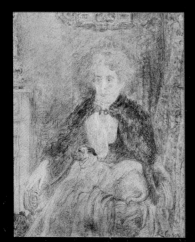

James Ensor, Portrait of Ensor's Mother, *1885. Black chalk and sanguine crayon. Musées Royaux des Beaux-Arts (Brussels, Belgium).*

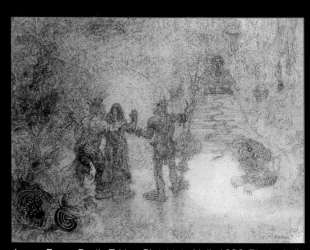

James Ensor, Devils Taking Christ into Hell, *1896. Black chalk. Musées Royaux des Beaux-Arts (Brussels, Belgium).*